Painting
Watercolour
Sea & Sky
the Easy Way

TERRY HARRISON

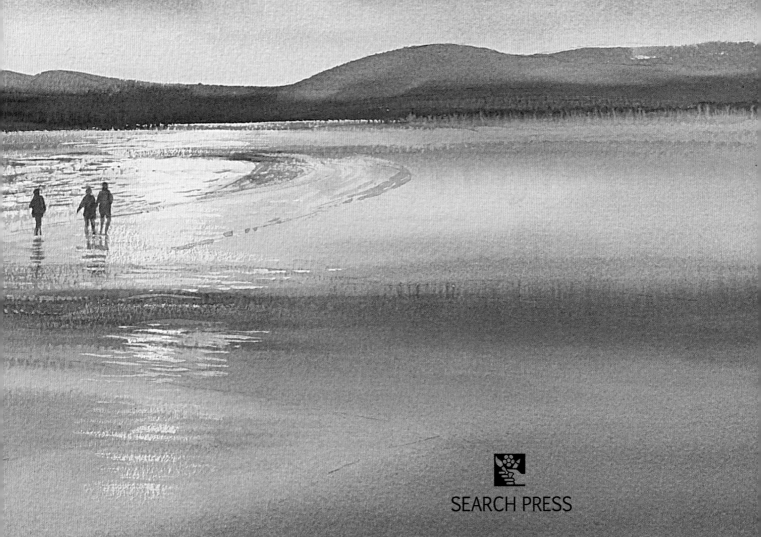

SEARCH PRESS

First published 2015

Search Press Limited
Wellwood, North Farm Road,
Tunbridge Wells, Kent TN2 3DR

Uses material from the following book published
by Search Press:

Terry Harrison's Sea & Sky in Watercolour, 2007

Text copyright © Terry Harrison 2015

Photographs by Roddy Paine Studios and by
Paul Bricknell at Search Press Studios
Photographs and design copyright © Search Press
Ltd. 2015

ISBN 978 1 84448 950 3

The Publishers and author can accept no
responsibility for any consequences arising from
the information, advice or instructions given in this
publication.

Suppliers
If you have any difficulty obtaining any of the
materials and equipment mentioned in this book,
please contact Terry Harrison at:

Telephone: +44 (0)1451 820014

Website: www.terryharrison.com

Alternatively, visit the Search Press website:

www.searchpress.com

Publishers' note
All the step-by-step photographs in this book feature
the author, Terry Harrison, demonstrating how to
paint with watercolours. No models have been used.

Printed in China

Dedication
This book is dedicated to my wife Fiona Peart
(Fiona Harrison). Thank you for navigating
me to safe waters when I've been all at sea,
and helping me see that the sky is the limit.

Acknowledgements
Thanks to Roddy Paine and Paul Bricknell for the
photography and thanks as always to my editor,
Sophie Kersey; she is like a lighthouse on a stormy
night, a true guiding light.
Also, as always, thanks to Fiona for typing.

Page 1:

Silver Surf

*The sunlight reflected on the water is emphasised by the
dark colours surrounding it. I have used white gouache to
adjust some lights in the surf, but most of the whites were
created using masking fluid. The highlight on the shoreline
rock was scraped away using a plastic card.*

Pages 2–3:

After the Storm

*As the storm clouds pass by, the beach combers are on
the look out for Neptune's treasures.*

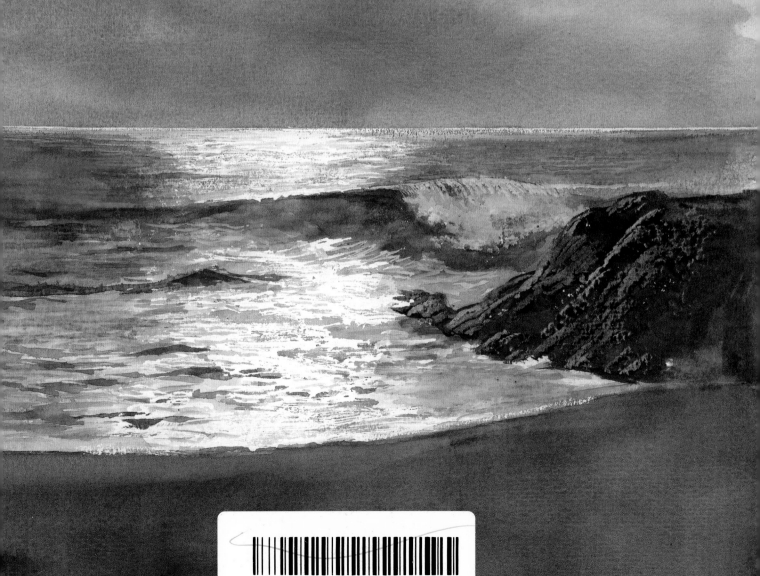

Painting
Watercolour
Sea & Sky
the Easy Way

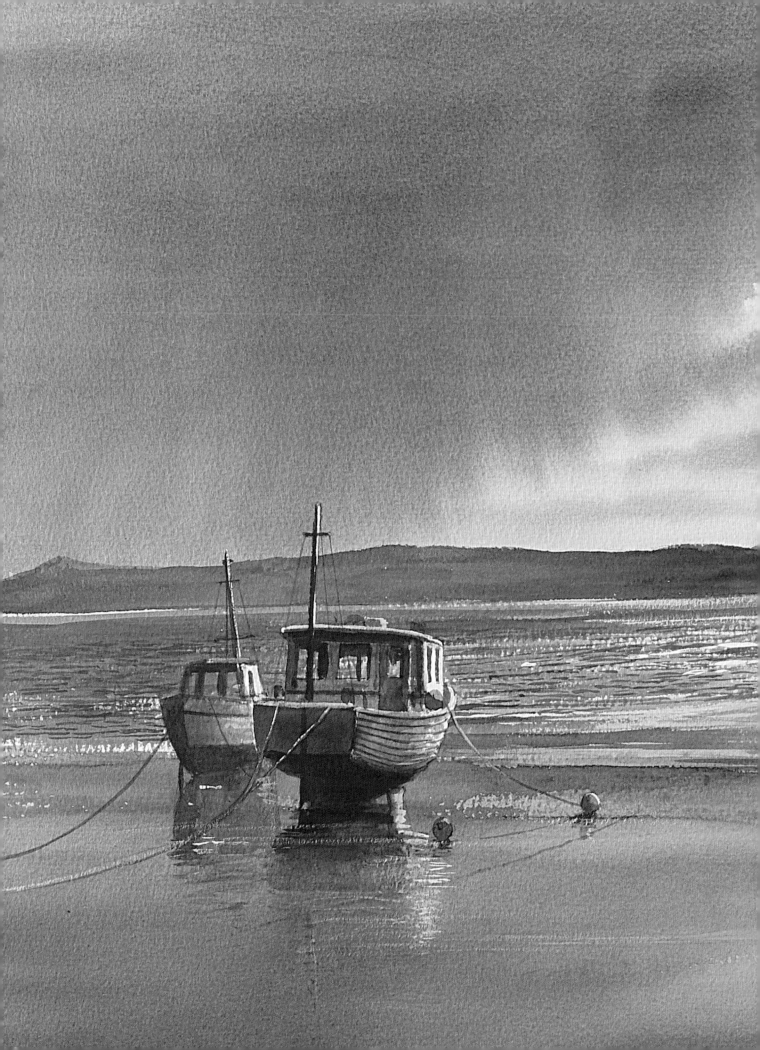

Contents

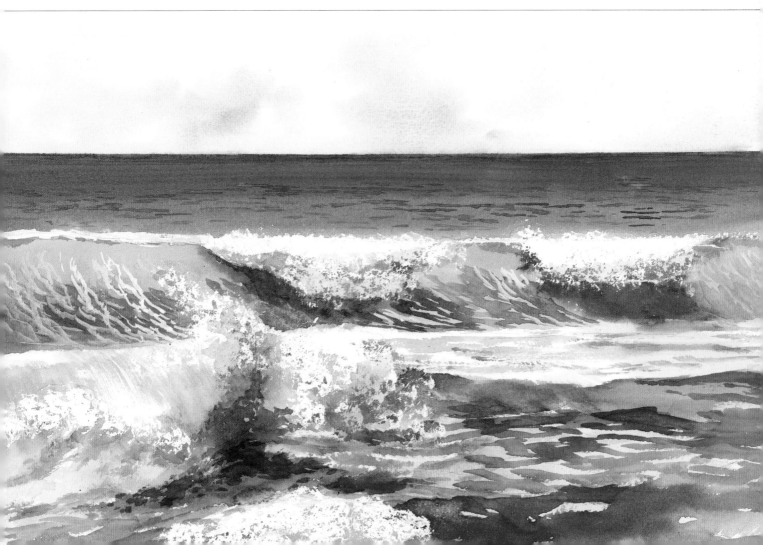

Introduction

I am not the type of artist that usually has his head in the clouds, but some days you just can't help yourself – I catch myself looking skywards and thinking, 'How would I paint that?'

Skies play an essential part in any landscape, and somehow combining an atmospheric sky with the drama of the sea can create the greatest free show on earth – never a repeat performance.

I don't know why I am attracted to painting seascapes, as I do live a fair way inland. However, this liking for the sea stems back to my childhood,

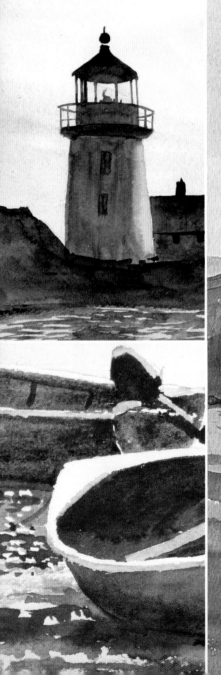

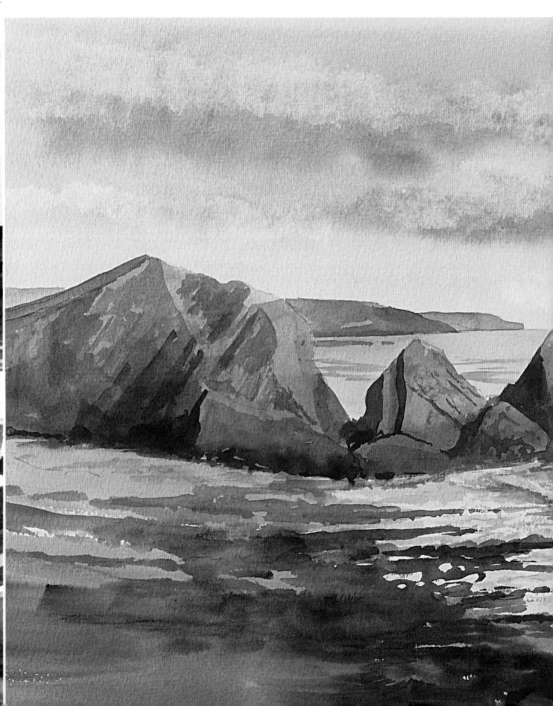

when my ambition at one stage was to join the Navy. This was dashed after living in Germany for a couple of years and travelling on cross-channel ferries, which always seemed to result in terrible seasickness. To this day I still have the same problem with sea-going craft: for example on a recent holiday in the Mediterranean I was physically ill on a pedalo.

In this book the intention is to show you some basic painting skills to achieve certain elements of a seascape or skyscape. Hopefully by learning to master the basic elements of these subjects, you can then develop dramatic paintings of your own – creating restless, moody, powerful seas with crashing breakers and jagged rocks!

Terry Harrison

Rocky Headland
72 x 33cm
(28½ x 13in)
This dramatic shoreline lends itself to a panoramic composition – long fingers of sharp teeth-like rocks stretching out into the incoming tide.

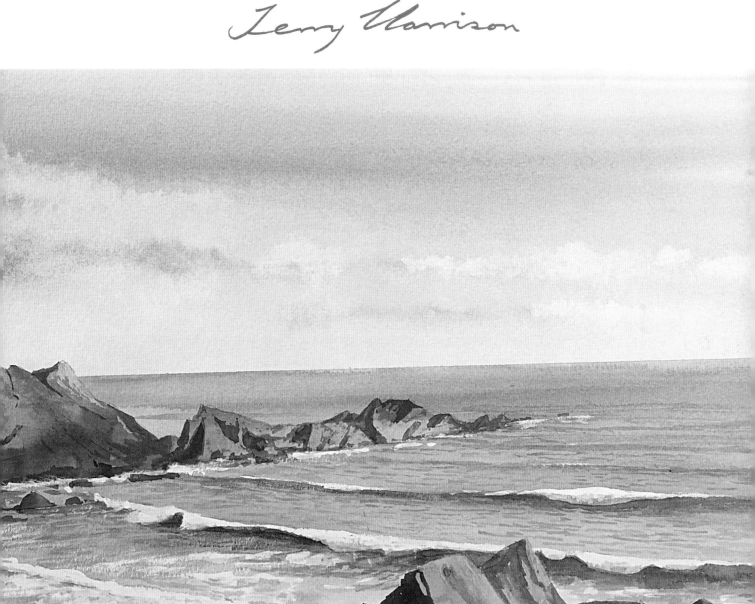

Materials

You will need a range of brushes and a selection of paints. I have used only one type of paper for the projects in this book, but you can use different weights and textures.

Paints

I always use artists' quality watercolours because they flow and mix better than the students' quality paints and give much better results. It is always advisable to buy the best paints you can afford. You can go a long way painting with only primary colours and a limited palette, but you may want to experiment with a wider range as you become more experienced.

Brushes

Some artists adapt brushes to suit their personal requirements. I have gone a step further than this and designed my own range of brushes, specially made to make good results easily achievable, and these are used throughout this book. Pages 14–15 show how each of these brushes can be used to create a range of effects which you will find useful when painting seas and skies.

Paper

Watercolour paper comes in different weights and in three surfaces: smooth (called hot-pressed or HP), semi-smooth (called Not) and rough. I usually use 300gsm (140lb) rough paper, because the texture is useful for many of my techniques. You can use Not paper of the same weight if you need a smoother surface for detailed work.

I never bother to stretch paper before painting. If a painting cockles as it dries, turn it face down on a smooth, clean surface and wipe the back all over with a damp cloth. Place a drawing board over it and weigh it down. Leave it to dry overnight and the cockling will disappear.

Other materials

Hairdryer

This can be used to speed up the drying process if you are short of time.

Masking fluid

This is applied to keep the paper white where you want to achieve effects such as ripples or foam in seascapes.

Soap

A bar of soap is useful to protect your brushes from masking fluid. Wet the brush and coat it in soap before dipping it in the masking fluid. When you have finished applying the masking fluid, it washes out of the brush with the soap.

Ruling pen

This can be used with masking fluid to create fine, straight lines.

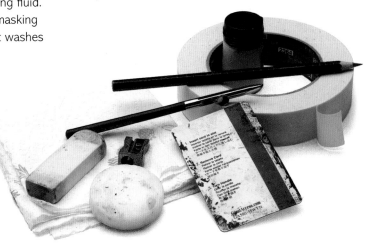

Masking tape

I use this to tape paintings to my drawing board, and to create a straight horizon.

Pencil and sharpener

A 2B pencil is best for sketching and drawing, and you should always keep it sharp.

Eraser

A hard eraser is useful for correcting mistakes and removing masking fluid.

Credit card

Use an old plastic card for scraping out texture when painting rocks and cliffs.

Kitchen paper

This is used to lift out wet paint, for instance when painting clouds.

Easel

This is my ancient box easel. You can stand at it, as I do, or fold the legs away and use it on a table top. There is a slide-out shelf that holds your palette. This particular one collapsed shortly after we photographed it, after twenty years' service, but I have used the good bits, together with another easel, to rebuild it.

Bucket

Your brushes need to be rinsed regularly. This trusty bucket goes with me on the painting demonstration circuit so that I am never short of water.

My palette

I limit myself to a fairly small range of colours, and with the range shown here I find that I can paint virtually any scene I choose. This selection includes a warm and a cool blue, three ready-made greens, one yellow, a good range of earth colours, a good strong red, permanent rose (a useful pink that is difficult to mix from other colours), alizarin crimson which is ideal for creating purple shades, and shadow which is a ready-made transparent mix that is ideal for painting shadows.

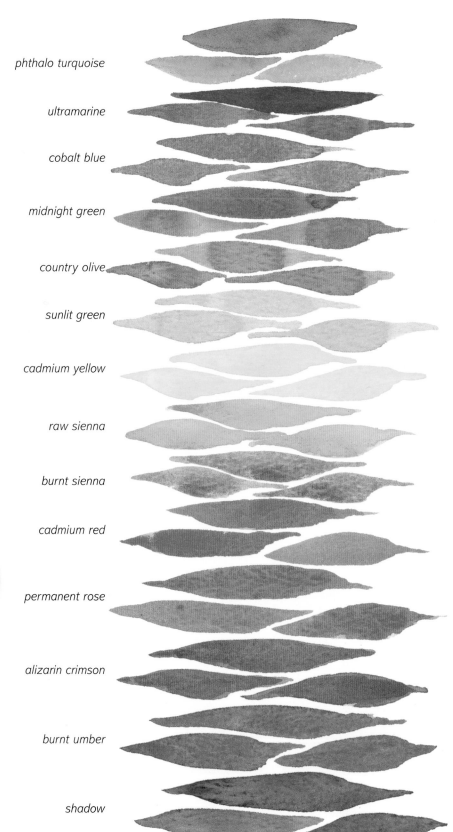

phthalo turquoise

ultramarine

cobalt blue

midnight green

country olive

sunlit green

cadmium yellow

raw sienna

burnt sienna

cadmium red

permanent rose

alizarin crimson

burnt umber

shadow

Useful mixes

The following colour mixes are useful for painting seas and skies in various different conditions.

Ultramarine and burnt umber make a good warm grey which is excellent for painting storm clouds.

Permanent rose and cadmium yellow make a good colour for a sky at sunset.

Ultramarine and midnight green make a good, deep sea colour.

Cobalt blue and sunlit green mixed together make a brighter sea colour for sunny conditions.

Using photographs

Let's be honest, most artists use photography as reference material; this is not cheating, it's simply the way it is done. It would be wonderful if we could just set off with our easels and painting gear tucked under our arms, and spend a lovely day painting by the seaside. In reality this is rarely possible; when you finally get to the coast, the weather has changed and the clouds are the wrong type, the wind has dropped and the sea is as flat as a mill pond, and to cap it all, the tide is out. Then there are moments when everything is right, and the only way to capture it in time is with a camera.

I always try to carry my camera with me at all times when I am searching for subjects to paint. A camera is an excellent way of capturing the moods of the sea: that moment when the wave breaks or that burst of spray shoots into the air. Many a time I have looked at a sunset and wished I had a camera.

Collect all your reference work and file it away ready for a rainy day when you just might need to be reminded what a wave or a sunset looks like.

You don't have to be a slave to your photographs; don't copy them exactly but use them as a guide or simply a starting point. Feel free to change them to create your own interpretation of the scene.

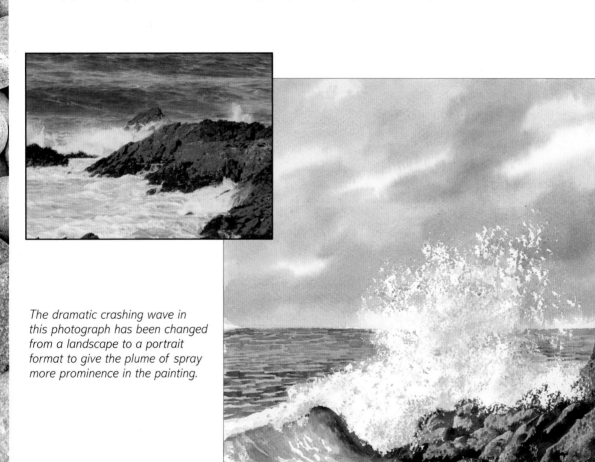

The dramatic crashing wave in this photograph has been changed from a landscape to a portrait format to give the plume of spray more prominence in the painting.

Combining photographs

Sometimes one photograph is not enough, so I combine two or three to create the effect I want. This painting combines two main elements placed together to create a much more dramatic subject; the rolling breaking wave is now crashing into the rocks on the shoreline, which gives the painting a much bigger splash.

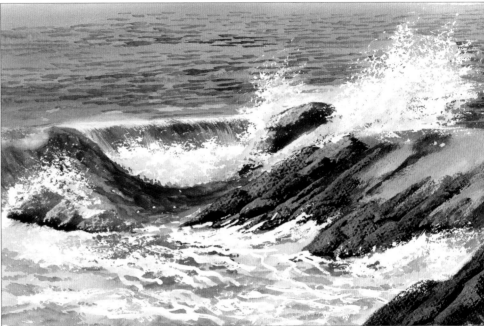

Adding colour

To add a bit of colour to the somewhat monotone photograph of a seaside pier, I have introduced a vivid sunset, which is also reflected in the foreground of the painting.

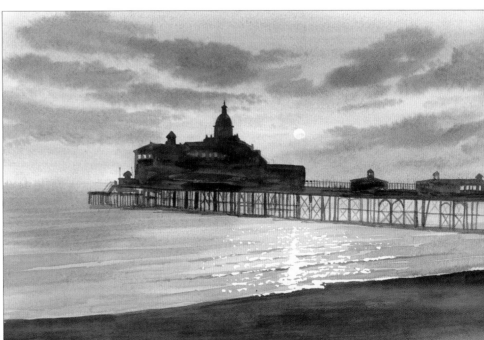

Techniques

Brush techniques

You can create wonderfully realistic effects using just the range of brushes shown here.

Large detail

This brush is useful for painting rippled water. Varying the amount of pressure you apply can create different effects.

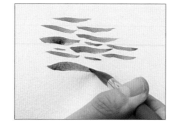

Flat brush

The 19mm (¾in) flat brush is useful for painting choppy water. Use a side to side motion with the tip of the brush.

Medium detail

This is ideal for painting smaller details such as ripples on water.

Small detail

This brush can be used to paint really small ripples on distant water.

Half-rigger

The half-rigger has a really fine point but holds a lot of paint. The hair is long, though not as long as a rigger. As its name suggests, this brush is excellent for painting the rigging on boats. You can use a ruler to steady your hand to achieve a straight, even line by running the ferrule (the metal part) along the edge of the ruler.

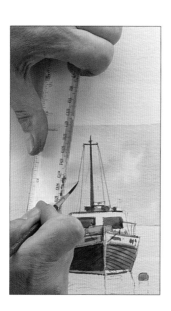

Golden leaf

This is a large wash brush which holds lots of paint and is ideal for painting washes and wet-in-wet skies. Use it to drop clouds into a wet wash.

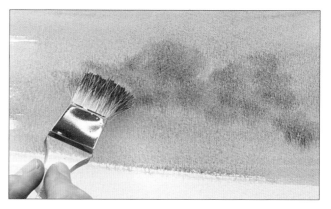

Foliage brush

Fan stippler

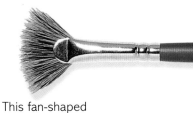

This smaller version of the golden leaf brush is good for painting foam bursts or adding texture to waves. You can also use it to paint shingle.

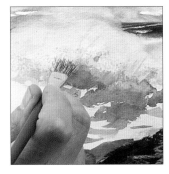

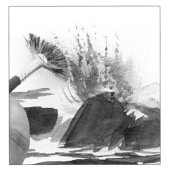

This fan-shaped version of the foliage brush is ideal for painting sea spray.

Wizard

Fan gogh

Twenty per cent of the hair in this brush is longer than the rest, which produces some interesting effects. To create reflections, paint a wash on first, then drag the brush down.

This thick fan brush is excellent for painting streaks in waves, and also for sand and grasses.

Grand Emperor

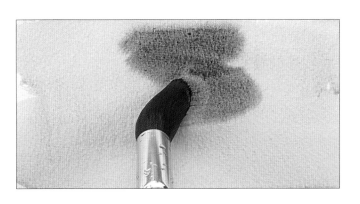

This large mop brush holds lots of paint and is good for washes and skies. It can be used for dropping a dark, stormy cloud into a wet sky wash.

Emperor extra large

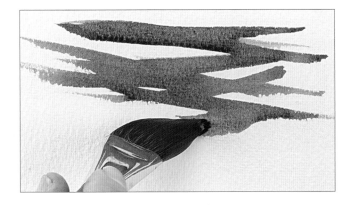

This large brush is useful for washes, but it also has a flat edge that is good for painting choppy water with a side-to-side motion.

Wet into wet

This involves putting wet paint on to a wet surface. The issue with this technique is how wet to make the initial wash. If there are puddles of water on the surface, it is too wet; the paper should just glisten. When adding paint to a wet surface, try not to overload the brush, or your paint will run away into the initial wash.

Sky

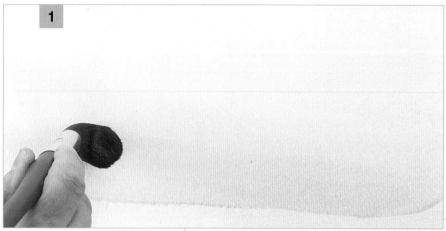

1 Wet the sky area with clean water using the Grand Emperor brush. Paint a thin wash of raw sienna on to the area near the horizon.

2 Mix ultramarine and burnt umber and streak it across the top of the sky.

Tip
If your brush is overloaded, remove the excess moisture by dabbing it on to some kitchen paper.

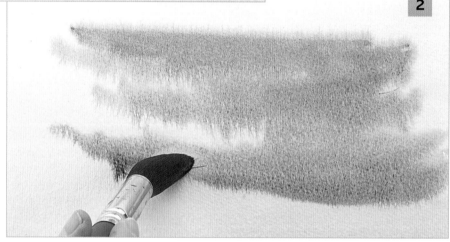

Sea

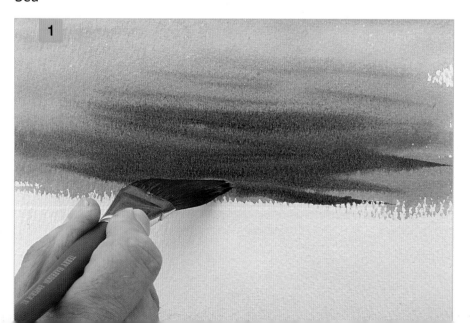

1 Use the Emperor extra large brush to apply a wash of cobalt blue. Then add streaks wet into wet using a stronger mix of ultramarine and midnight green.

Opposite
Passing Storm
The wet into wet technique is ideal for painting big, soft-edged clouds and gentle rolling seas.

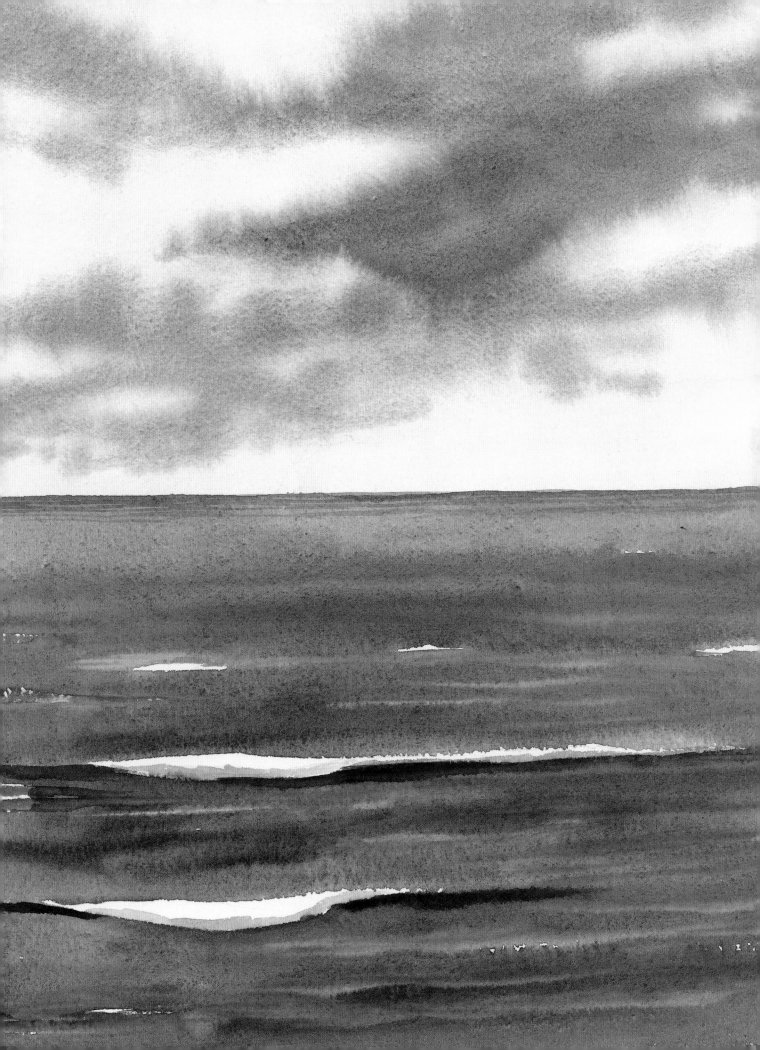

Wet on dry

I know this is going to sound obvious, but this technique involves putting wet paint on to a dry surface. Skies are often painted wet into wet, but using a wet on dry technique gives you the option of adding detail in a more controlled way once your sky has dried. When painting seas, you can use this technique to add details such as ripples in sharp contrast with the background colour. If you did this wet into wet, the detail would dissolve into the background wash.

Sky

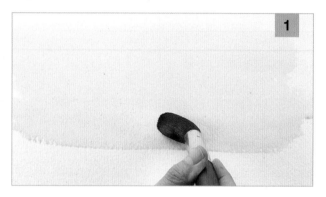

1 Use the Grand Emperor brush to apply a wash of raw sienna and allow it to dry.

2 Paint on clouds using a mix of ultramarine and burnt umber. Painting wet on dry in this way creates harder edges.

Sea

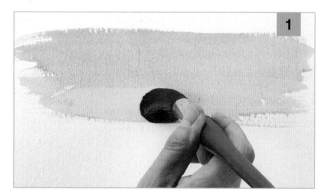

1 Paint on a wash using the Grand Emperor brush and allow it to dry.

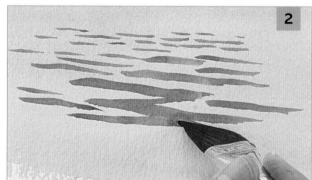

2 Paint on ripples using the tip of the Emperor extra large brush, moving it from side to side as shown.

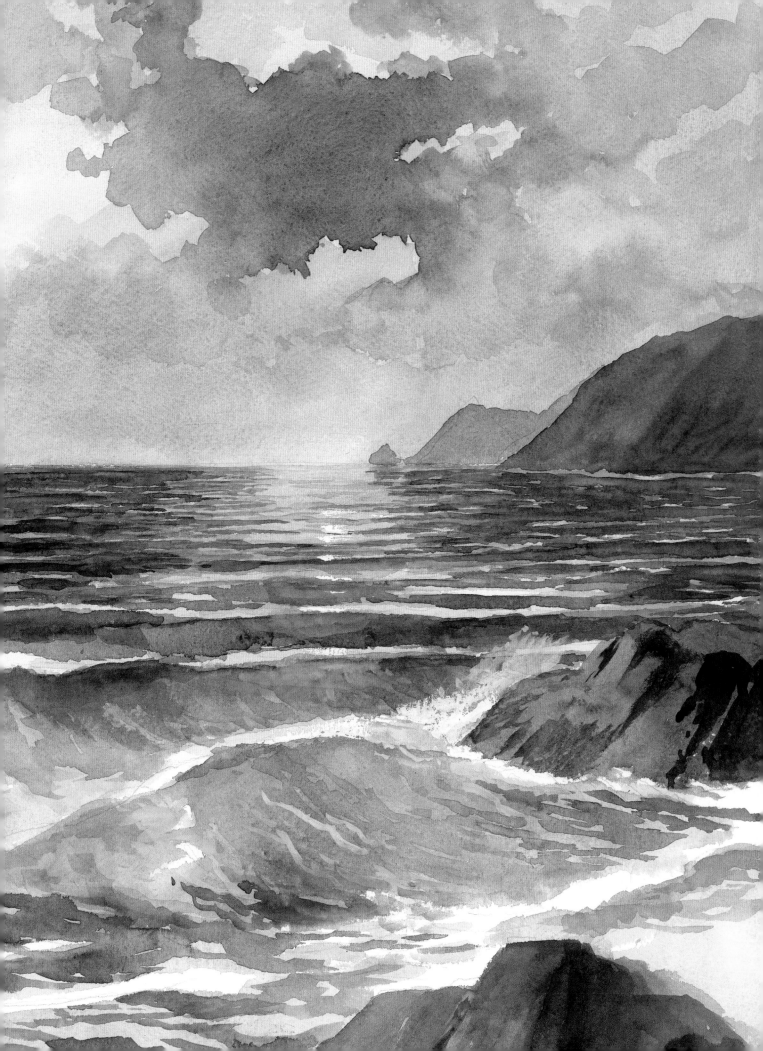

Lifting out

This is a technique to remove surface paint using a sponge or kitchen paper while the paint is still wet.

Spray

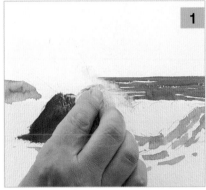

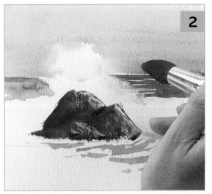

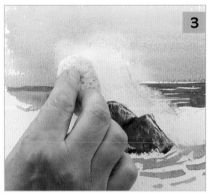

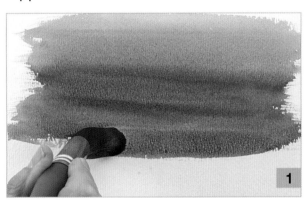

1 Use a slightly damp sponge to lift out the background sea painting to suggest spray from a wave hitting the rock.

2 Use the Grand Emperor brush to wash in the sky, leaving a gap for the spray where it will show against the sky.

3 While the sky wash is wet, use the sponge again to lift out the spray area. Allow the painting to dry.

4 Use the foliage brush and a blue mix to paint in the texture of the spray.

Ripples

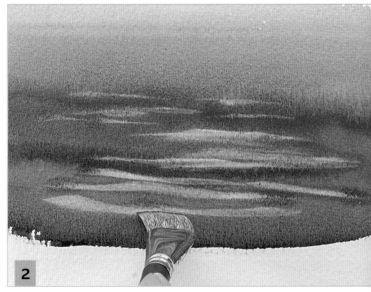

1 Paint on a wash for the water with the Grand Emperor brush.

2 While the wash is wet, take the 19mm (¾in) flat brush, wet it and squeeze out the water. Lift out ripples with a side-to-side motion.

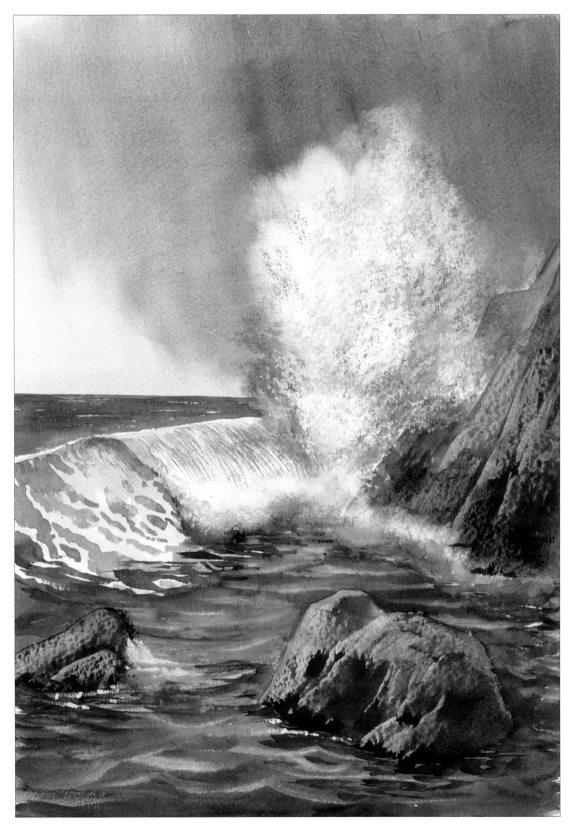

Spray in the Air

Lifting out will give you a much softer image, which is ideal for painting spray. Here, the foreground ripples were lifted out. This is a very simple and effective technique to capture the movement of the swell.

Using masking fluid

Foam and ripples

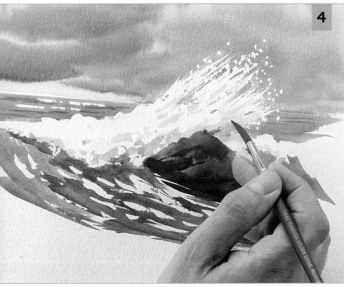

1 Use an old brush and a flicking motion to mask out the foam, the ripples and the crests of distant waves.

2 Paint clean water on to the sky area using the Grand Emperor brush, then apply a wash of raw sienna. Mix ultramarine and burnt umber and paint in dark clouds wet into wet, going over the masking fluid.

3 Use the 19mm (¾in) flat brush and a mix of ultramarine and burnt umber to paint the rock. Paint the sea in the foreground using the 19mm (¾in) flat brush and a side-to-side motion.

4 When the paint is dry, remove all the masking fluid with clean, dry fingers. Use the medium detail brush and a thin mix of cobalt blue and midnight green to add detail to the foam.

Gulls

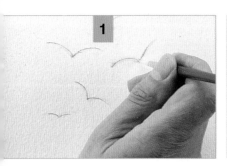
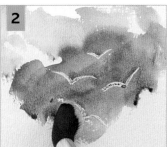
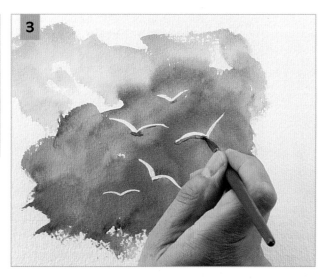

1 Use an old brush and masking fluid to mask out the gulls.

2 Use the Grand Emperor brush and ultramarine and burnt umber to paint the sky.

3 Rub off the masking fluid and add shading to the gulls using the medium detail brush.

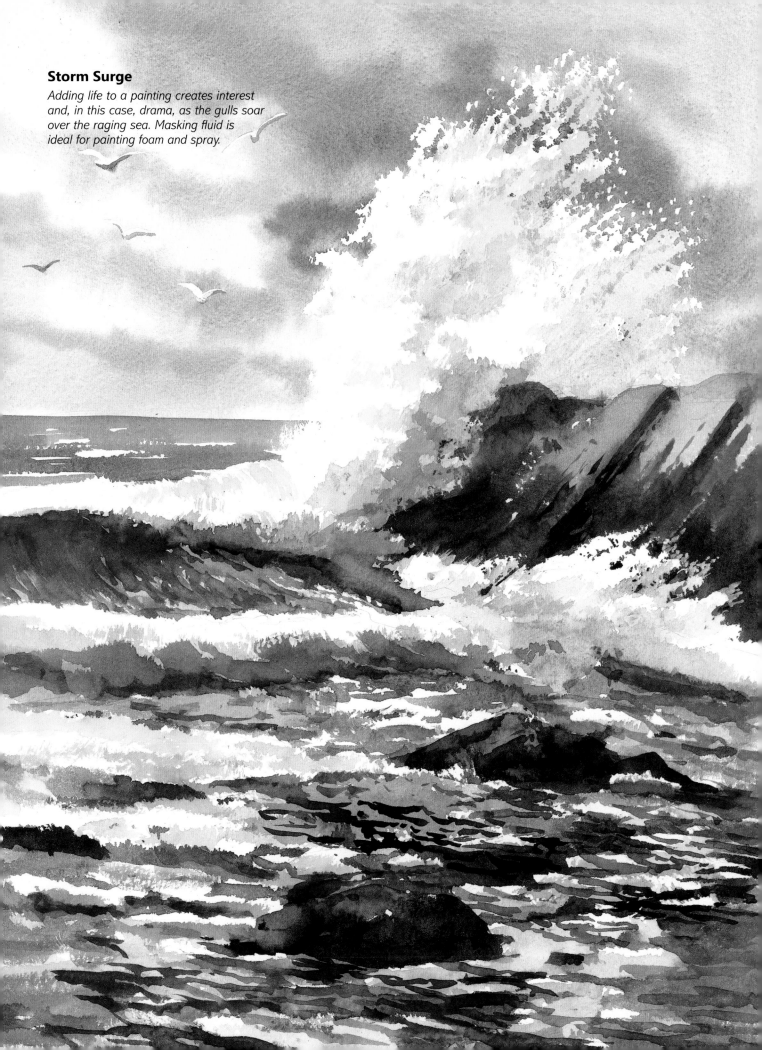

Storm Surge

Adding life to a painting creates interest and, in this case, drama, as the gulls soar over the raging sea. Masking fluid is ideal for painting foam and spray.

Painting seas

In this section you will learn how to paint the sea in its many moods, from calm water with barely a ripple, or a choppy sea swell, to waves breaking on the shore or crashing against rocks, causing bursts of foam and spray. You will also learn to paint the horizon, shorelines and the bands of colour that make seascapes vibrant and realistic.

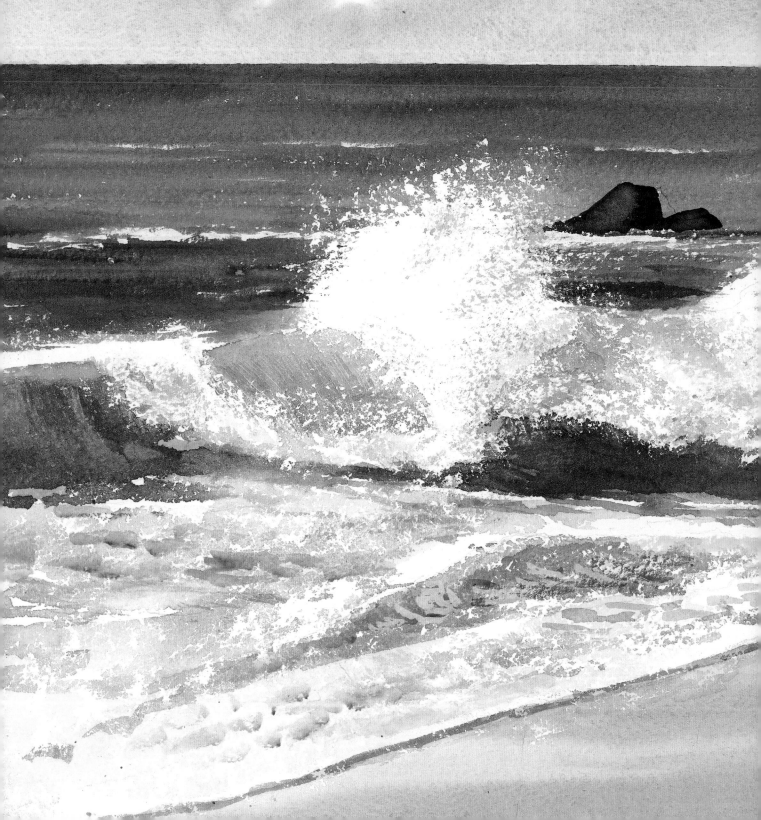

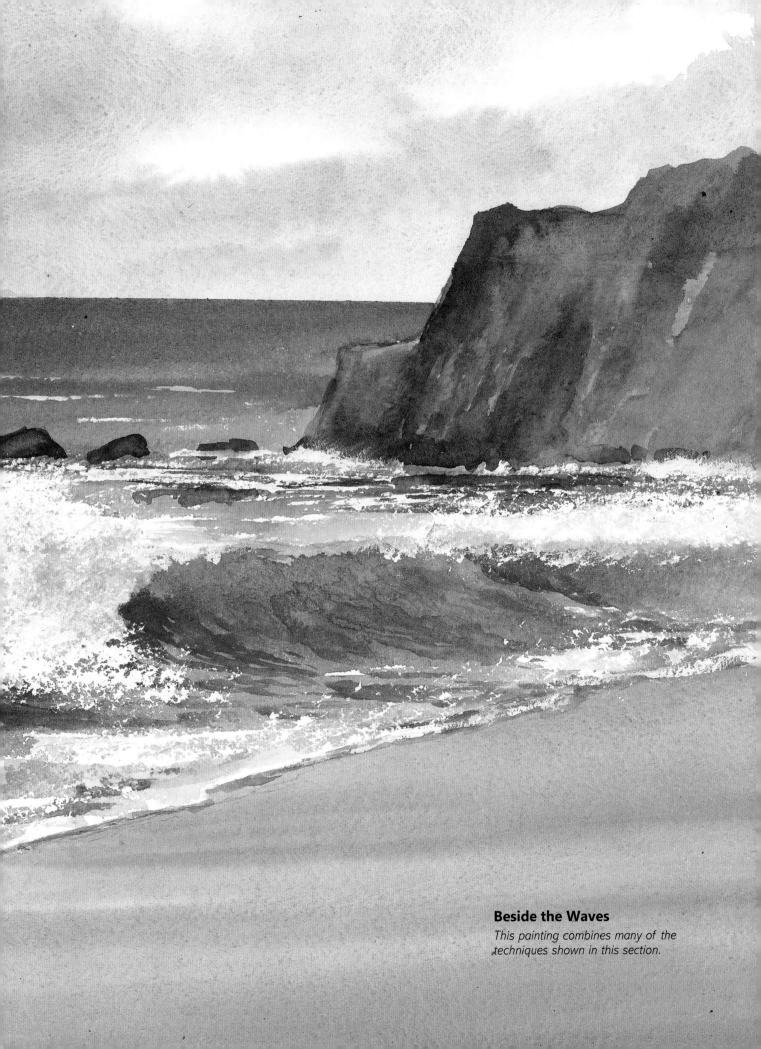

Beside the Waves

This painting combines many of the techniques shown in this section.

Calm water

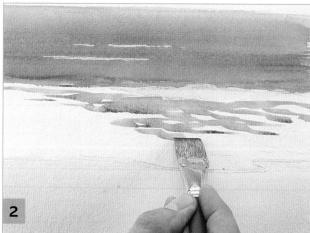

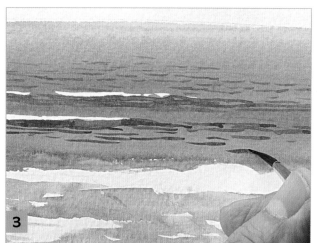

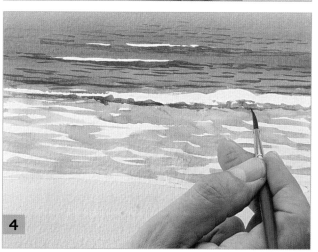

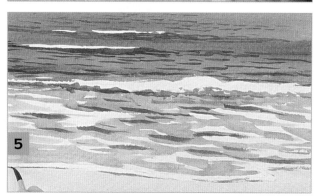

1 Paint masking fluid on to the wave crests and the surf. Paint on clear water and then raw sienna for the beach using a 19mm (¾in) flat brush. Paint the sea with ultramarine near the horizon, mixed with midnight green as you come forwards.

2 Use the tip of the flat brush and a side-to-side motion to paint ripples in the surf.

3 Rub off the masking fluid and use the small detail brush and ultramarine to paint distant ripples. Add midnight green to the mix and paint the darker colour under the crests of the small waves. Add ripples.

4 Use cobalt blue to paint shading under the crest of the foreground wave.

5 Use the ultramarine and midnight green mix to paint darker ripples in the foreground foam. Paint a broken line of the darker blue mix under the surf on the wet sand.

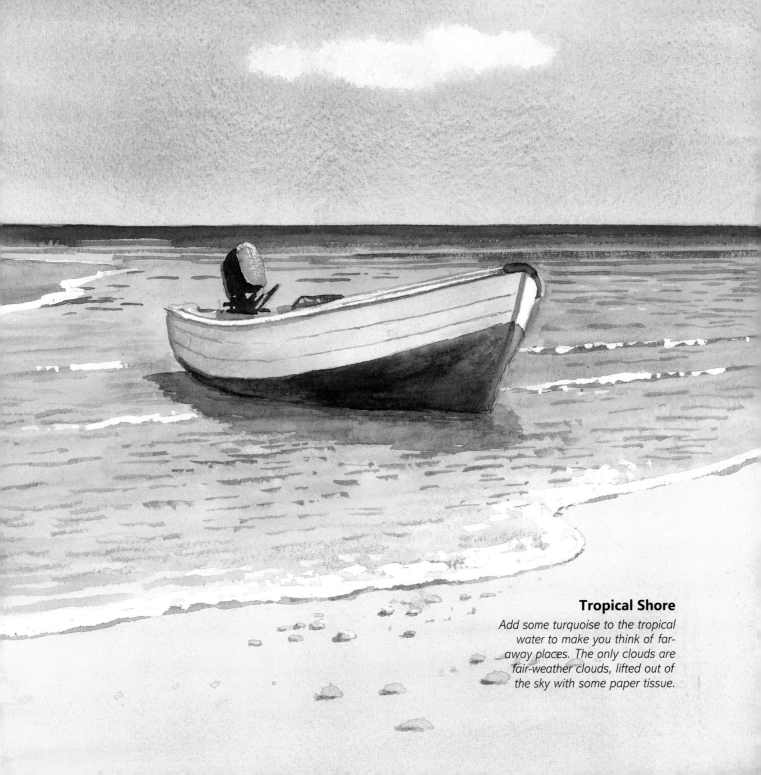

Tropical Shore

Add some turquoise to the tropical water to make you think of far-away places. The only clouds are fair-weather clouds, lifted out of the sky with some paper tissue.

Choppy water

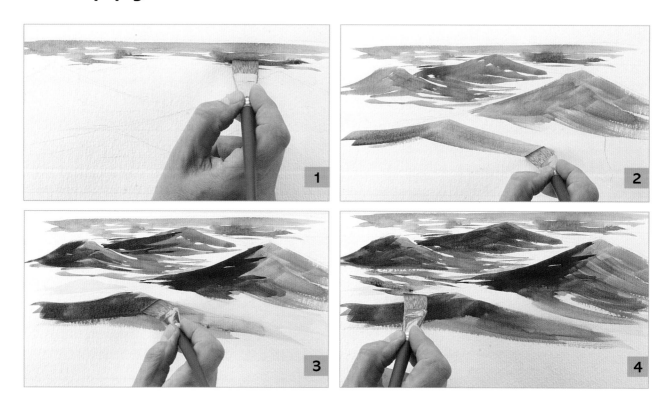

1 Paint ripples with the 19mm (¾in) flat brush and ultramarine.

2 Using ultramarine and a touch of midnight green, paint in the peaks and troughs.

3 Add more midnight green to the mix and paint in the shaded sides of the waves.

4 Use a pale wash of ultramarine and midnight green to paint ripples in the troughs between waves. This suggests a reflection of the sky.

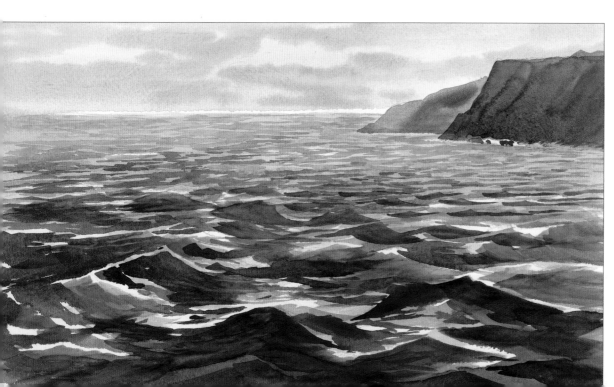

A Slight Swell

The sea is quite dark in the foreground, with large choppy waves. As the eye is led into the painting, the waves become smaller and lighter in colour, with more of a tint of blue as opposed to the green further forwards.

Breaking waves

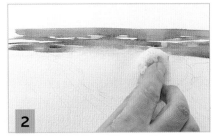
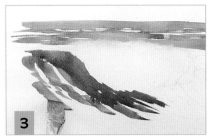
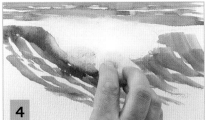
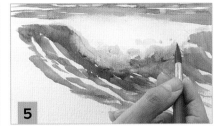
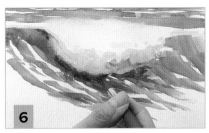

1 Take the 19mm (¾in) flat brush and paint ripples up to the top of the wave.

2 While the paint is wet, soften the top of the wave area using a damp sponge.

3 Paint the dark part of the wave, leaving some white streaks to imply foam.

4 While the paint is wet, soften the edge of the wave using the damp sponge. Make sure the sponge is clean each time you use it.

5 Using the large detail brush and a thin wash of cobalt blue, paint shading in the foam at the edge of the wave.

6 Allow the paint to dry. Mix ultramarine and midnight green to make a stronger blue and shade under the foam.

Misty Waves

The fine spray of a breaking wave as it rolls into shore is easily captured by using a damp sponge to lift out some pigment while the paint is still wet.

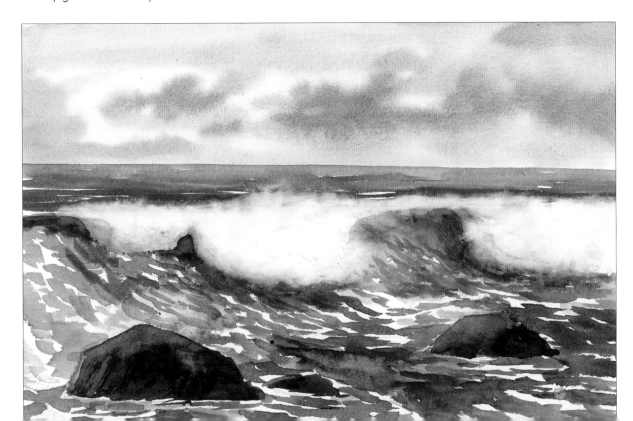

Crashing waves

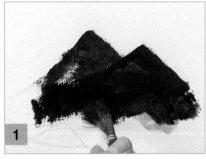

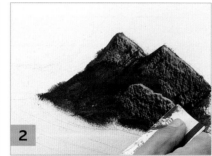

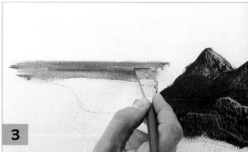

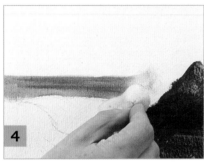

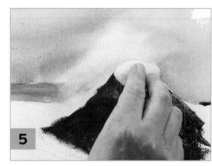

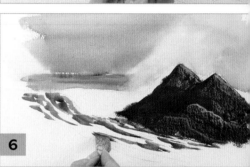

1 Use the foliage brush to paint a thick mix of raw sienna on to the rocks. Paint a strong mix of ultramarine and burnt umber on top.

2 Use an old plastic card to scrape out rock shapes. This technique works best with rough surfaced paper. Allow to dry.

3 Use the 19mm (¾in) flat brush to paint clean water on the horizon area. Then paint on a mix of ultramarine and midnight green.

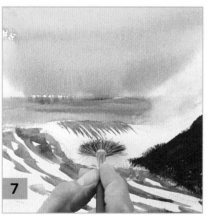

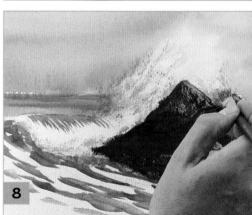

4 Lift out the area around the rock with a damp sponge to suggest spray. Allow to dry.

5 Use the Grand Emperor and raw sienna to paint the sky. Paint dark clouds using a mix of burnt umber and ultramarine. While the paint is wet, use the damp, clean sponge to lift out the spray around the rock.

6 Use the 19mm (¾in) flat brush and a mix of ultramarine and midnight green to paint ripples at the base of the rocks, leaving white paper to suggest foam.

7 Use the fan gogh brush and the same mix to pull streaks over from the back of the wave forwards. Allow the paint to dry.

8 Take the foliage brush and use cobalt blue to add detail to the spray around the rock.

A shoreline

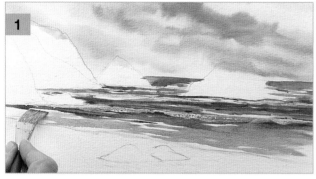

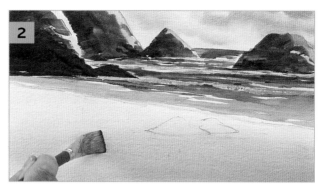

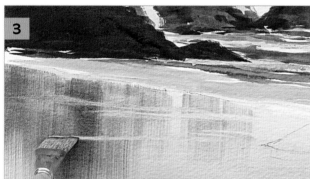

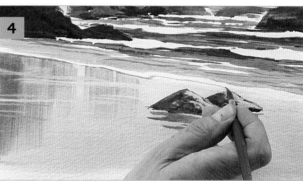

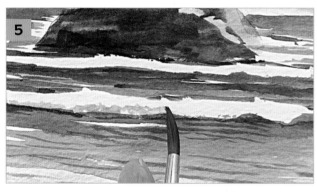

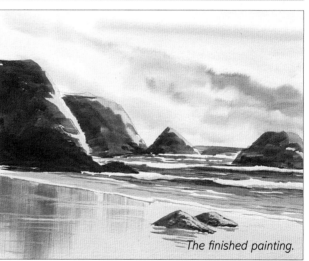

The finished painting.

1 Mask the crests of the waves. Paint the sky (see Painting skies from page 34). Use the 19mm (¾in) flat brush and ultramarine with midnight green to paint distant rippled water. Use paler cobalt blue to paint rippled water in the foreground.

2 Paint the sunlit sides of the rocks with raw sienna. Then paint on ultramarine and burnt umber for the darker parts. Wet the beach and paint a wash of raw sienna on to the lower part.

3 Pick up the ultramarine and burnt umber mix with the flat brush and drag the colour down to create reflections. Clean and squeeze the brush, and use it damp to lift out ripples on the wet beach.

4 Use raw sienna, then burnt umber and ultramarine and the plastic card technique (see page 44) to paint rocks. Use the 19mm (¾in) flat brush and the dark rock mix to paint reflections. Change to the medium detail brush and a mix of ultramarine and midnight green to paint shadow under the crests of the waves, and a broken line under the edge of the surf.

5 Use cobalt blue to apply light texture to the foam.

Bands of colour

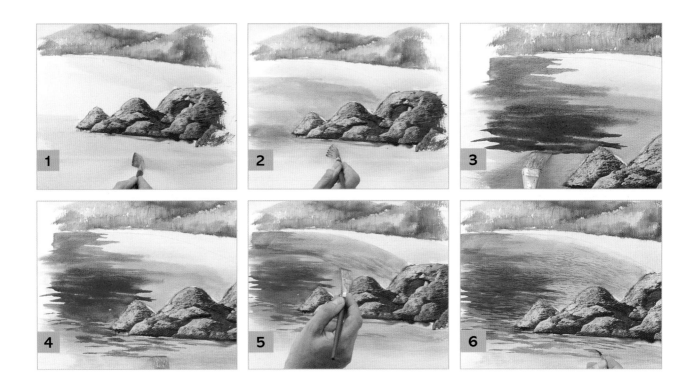

1 Paint the sky and background and then paint rocks using the plastic card technique shown on page 44. Use the 19mm (¾in) flat brush to paint a wash of raw sienna for the distant beach. Water down the mix towards the sea. Repeat for the foreground beach.

2 When the beach area is dry, wet the sea area with clean water and paint a wash of cobalt green deep in the background. Paint with cobalt blue further forward, wet into wet. Paint a wash of cobalt blue and cobalt green over the foreground.

3 While the foreground is wet, paint ripples with a mix of ultramarine and midnight green. Add cobalt blue and cobalt green wet into wet with the flat part of the brush.

4 Use the ultramarine and midnight green mix to paint ripples in the foreground. Allow the painting to dry.

5 Wet the sea area and drag cobalt blue and cobalt green across it, following the direction of the shoreline. Allow to dry.

6 Use the small detail brush to add ripples with a mix of ultramarine and midnight green.

The finished painting.

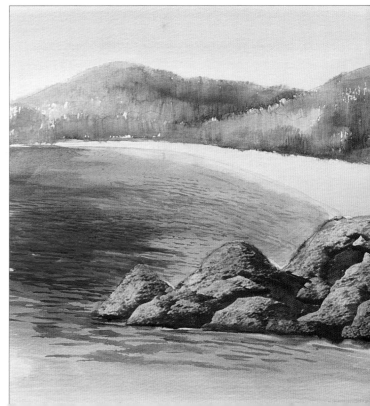

The horizon

The most important thing about the sea horizon is that it must always be straight and never sloping. When applying the masking tape, put a pencil mark at one end of the horizon, then measure the same distance from the top of the paper at the other end and put a similar mark. Then you just need to join the dots!

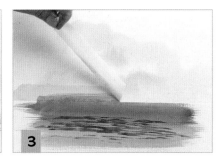

1 Paint the sky (see Painting skies from page 34) and allow to dry. Apply masking tape to the bottom, with the lower edge where you want the horizon to be. Use the 19mm (¾in) flat brush to paint on a mix of ultramarine and midnight green for the sea. Go over the lower edge only of the masking tape. Leave to dry.

2 Make a stronger, darker mix of the same colours and paint from side to side with the flat brush to create ripples.

3 Remove the masking tape to reveal the straight horizon. Always pull away from the horizon line.

Tip
You can buy low-tack masking tape, which reduces the risk of tearing the surface of the paper.

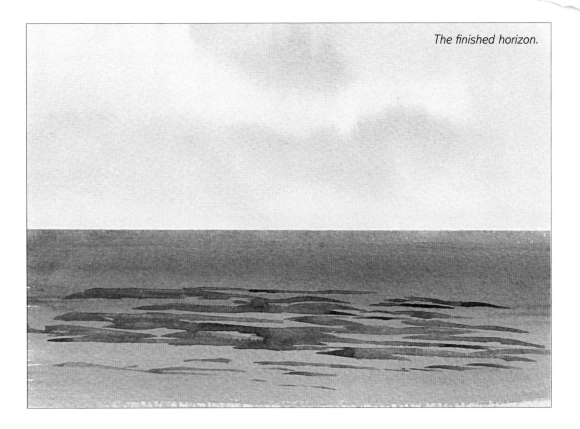

The finished horizon.

Painting skies

Many artists before me have said that to improve your skies you should paint a sky a day –
I heartily concur but let's face it – who's going to do that? However, the sky will almost
always play a role in any landscape or seascape – this can be a large dramatic role, or a
small supporting part. In this section you will learn how to paint clear, cloudy, stormy and
sunset skies. Skies don't usually appear on their own, however, and there is also advice on
painting reflections, rocks, shingle, sand dunes, cliffs, lighthouses and boats to complete
your seascapes.

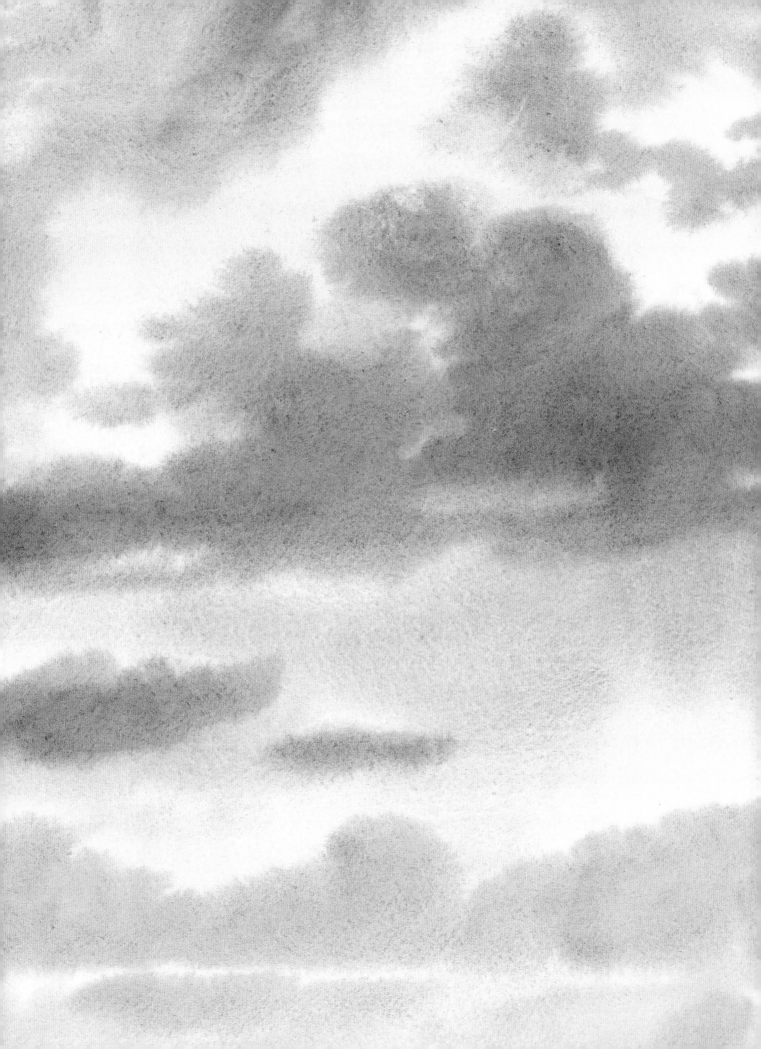

A clear sky

Most artists look for clouds or something to inspire you to get your brushes out – but sometimes the sky is just clear, so it is worth knowing how to paint a clear blue sky.

1 Wet the sky area first with clean water and the golden leaf brush. Load the brush evenly with a wash of ultramarine. Start at the top and paint from side to side.

2 As you continue down the paper, the sky gets lighter as there is less colour on the brush. The wet into wet technique disperses any streaks.

A cloudy sky

This is a simple cloudy sky that would look good in most paintings.

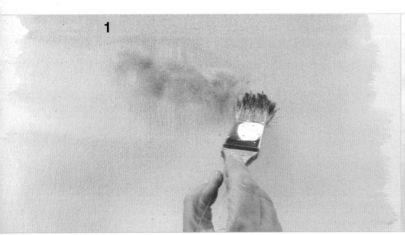

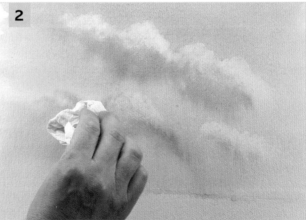

1 Wet the area first with clean water. Paint on a wash of ultramarine with the golden leaf brush. Mix ultramarine and burnt umber to make grey, and paint clouds into the wet background.

2 Use a pad of kitchen paper to lift the colour out of the tops of the clouds.

The effects will continue to develop as the sky dries.

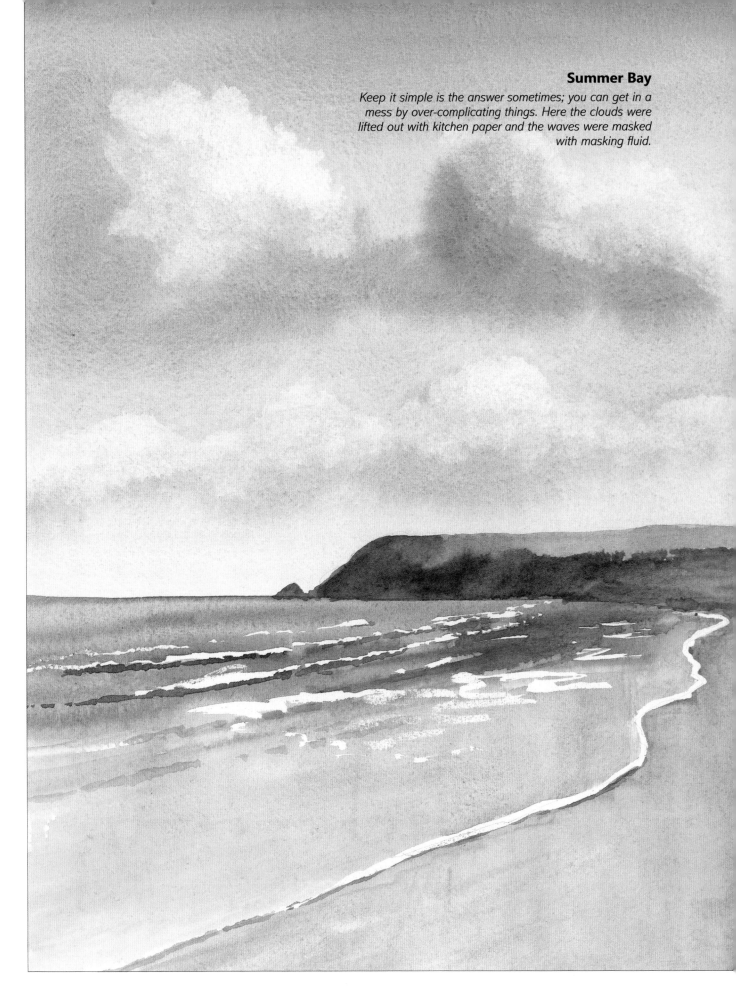

Summer Bay
Keep it simple is the answer sometimes; you can get in a mess by over-complicating things. Here the clouds were lifted out with kitchen paper and the waves were masked with masking fluid.

A stormy sky

This can create atmosphere in a scene, which could be essential to the painting – for example when creating a storm at sea, or a weather front moving across the moorlands.

1 Paint on clean water. Then paint on patches of raw sienna with the golden leaf brush.

2 Paint dark clouds wet into wet using a mix of ultramarine and burnt umber.

3 Use a darker mix of ultramarine, burnt umber and a touch of crimson to paint darker clouds, still working wet into wet.

4 Add more dark clouds to finish the sky.

Opposite

Wet Sand at Low Tide

The storm clouds roll in over the coast, creating reflections on the wet sand at low tide. The sky and beach were painted first, wet into wet, then the shoreline and sea were added once the painting was dry.

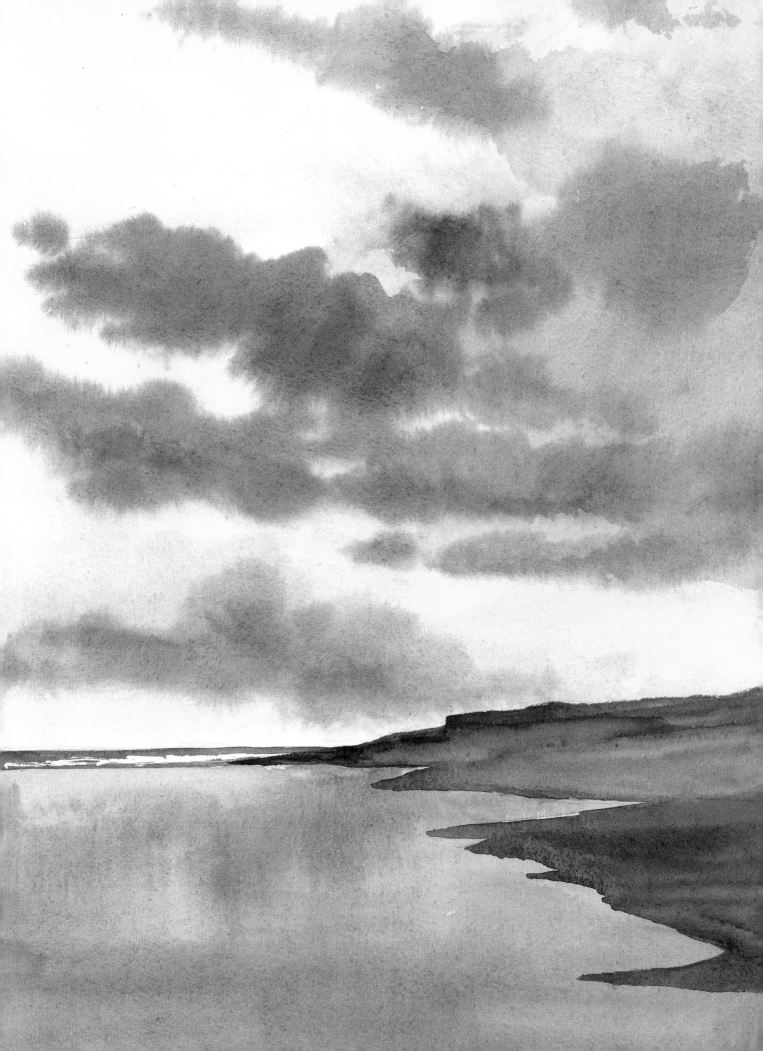

Another cloudy sky

This version of a cloudy sky also uses wet into wet and lifting out techniques, but this time the shapes of the clouds are suggested in the initial wash. This is a more controlled method of painting clouds, giving greater definition to your sky.

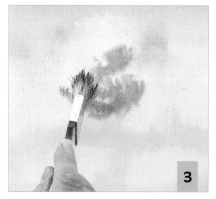

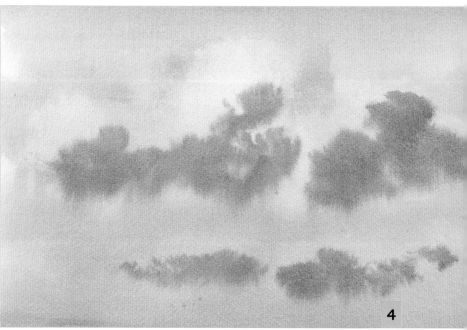

1 Wet the sky area with clean water. Take the golden leaf brush and a wash of ultramarine, and paint a sky, leaving white spaces for clouds.

2 Tidy up the edges of the clouds by lifting out colour using kitchen paper. Allow the painting to dry.

3 Wet the whole sky area again with clean water. Pick up a mix of ultramarine and burnt umber and touch in shadows at the bottom of the clouds.

4 Continue adding shadows until you are happy with the effect.

A sunset

Sunsets are very popular and because no two are ever the same, this provides endless scope for producing dramatic, atmospheric skies.

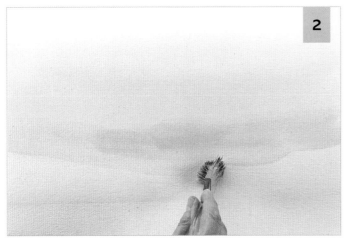

1 Wet the sky area with clean water. Use the golden leaf brush to apply cadmium yellow across the middle of the sky. Paint a band of cadmium red wet into wet, under the yellow.

2 Above the band of yellow, paint alizarin crimson wet into wet, fading it into the yellow.

3 Still working wet into wet, paint cobalt blue at the top of the sky, running down into the alizarin crimson. In this way you avoid accidentally creating green by mixing the blue with the yellow.

4 Working quickly, wet into wet, drop in shadow colour to create dark clouds. Create a v-shaped cloud formation, making sure that there are smaller clouds lower down the sky, as this helps to create the illusion of distance.

Painting reflections

The technique I am going to show you in this step-by-step demonstration is a fairly simple process, but produces more than a complete mirror image. It is easy to achieve, but very effective.

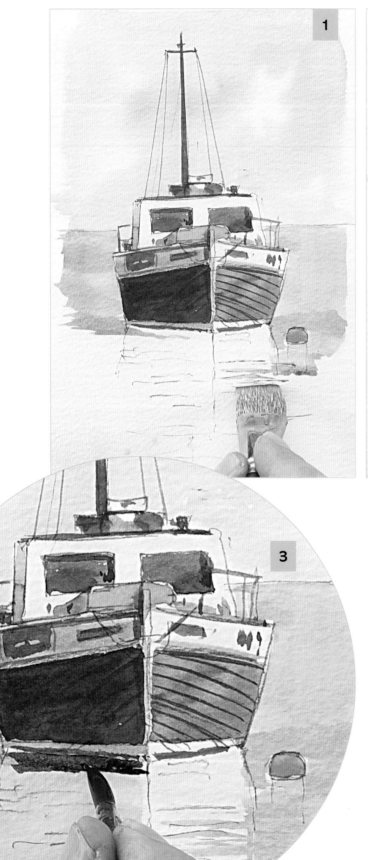

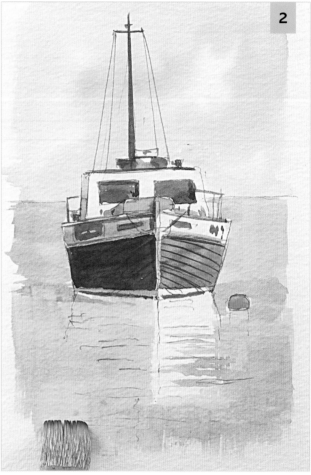

1 Paint the boat and the sky first. Paint the rigging using a half-rigger brush and a ruler to achieve thin, straight lines. Take the 19mm (¾in) flat brush and paint the water with a light wash of cobalt blue. Paint ripples and leave white paper to suggest reflections of the white boat.

2 Drag down the colour at the bottom of the water area.

3 Paint the reflection of the dark side of the boat using a mix of ultramarine and burnt umber and the medium detail brush. The reflection should be quite solid close to the boat.

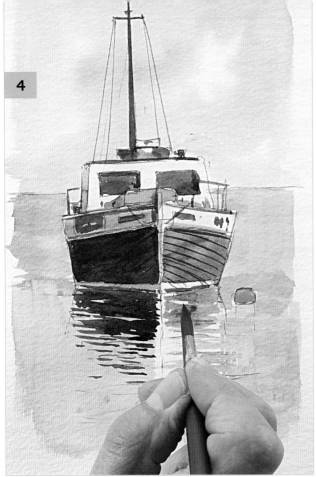

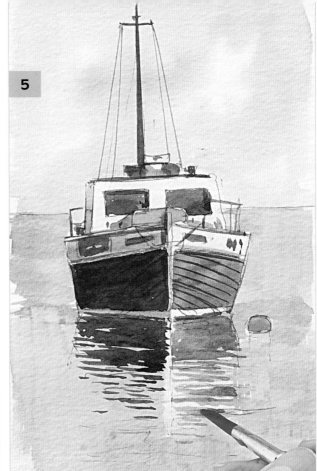

4 Further down, paint ripples as the reflection becomes less solid. Use a lighter mix of cobalt blue to paint the reflection of the right side of the boat in the same way.

5 Paint looser, light blue ripples further down the water.

6 Finally, paint the reflection of the buoy using cadmium red.

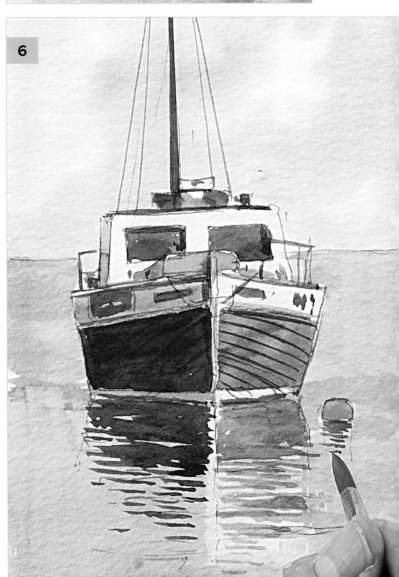

Other elements

When painting a seascape, there is much more to the painting than just the sky and the water. Here I show you a small selection of useful techniques that will help you achieve a realistic seascape.

Rocks

This technique uses a plastic card such as a credit card. The colours used in this example are quite warm, but if you want to achieve a cooler effect, use colours such as blue and grey.

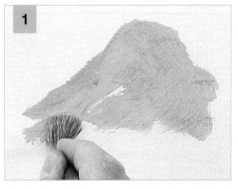

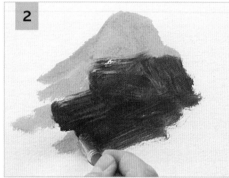

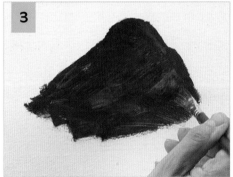

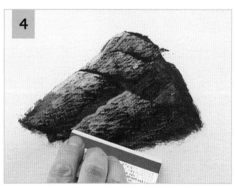

1 Paint the rock shape using a thick mix of raw sienna and the stiff-haired foliage brush.

2 Paint a dry mix of burnt umber on top.

3 Mix ultramarine and burnt umber and paint over the whole rock.

4 Use a plastic card to scrape the surface of the rock, leaving gaps as shown to suggest crevices.

Tip
Use hardly any water with the paint for this technique. It will not work with wet paint mixes.

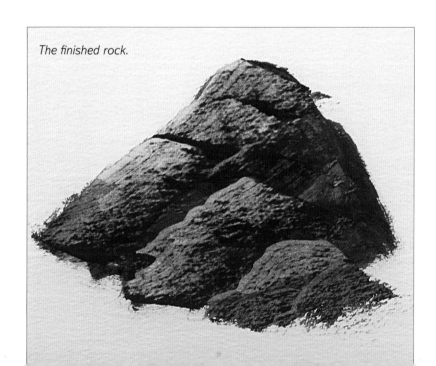

The finished rock.

Shingle

To achieve successful shingle, it is essential to create a textured effect. This is a simple technique, just using the foliage brush.

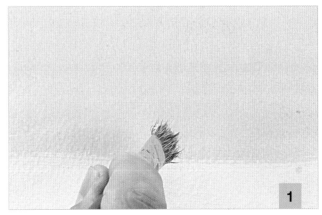

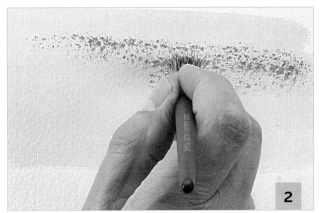

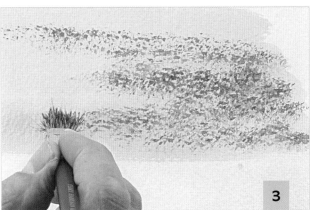

1 Paint on a thin wash of raw sienna using the foliage brush and allow it to dry.

2 Use the foliage brush to stipple on burnt umber to suggest the texture of the shingle.

3 Mix burnt umber and ultramarine and stipple this darker mix on top.

Sand dunes

The introduction of sand dunes to a painting can create interest in the foreground, which will lead you into the scene.

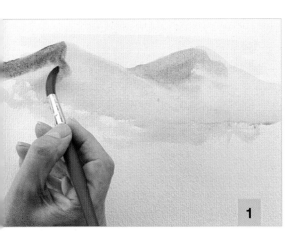

1 Paint on a light wash of raw sienna with the large detail brush, then paint in the dunes with a stronger mix. Paint the shaded sides of the dunes with shadow colour, wet into wet. Allow to dry.

2 Use the fan gogh brush and midnight green to flick up grasses in the dunes.

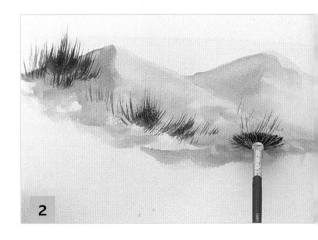

Cliffs

Again, this uses the plastic card technique to create the different faces of the cliff.

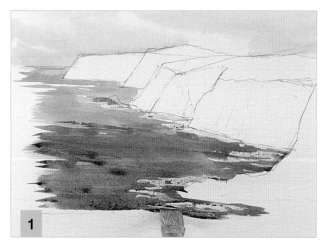

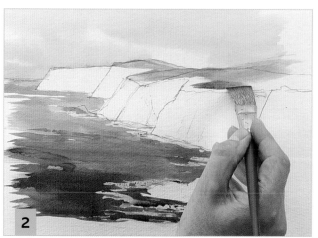

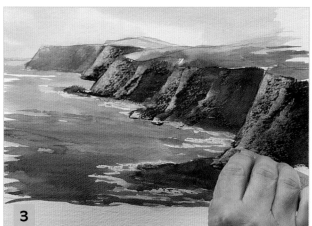

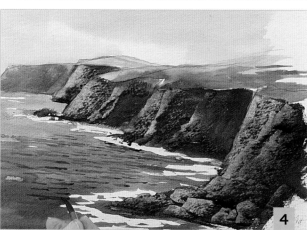

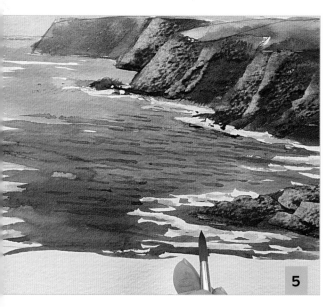

1 Mask the surf at the water's edge using masking fluid. Paint the sky (Painting skies, page 34). Use the 19mm (¾in) flat brush and ultramarine with midnight green to paint the sea with a side-to-side motion. Add more midnight green towards the foreground.

2 Paint a thin mix of country olive and ultramarine on the headland, making the mix stronger in the foreground.

3 Paint thick raw sienna on the cliffs, then an ultramarine and burnt umber mix. Scrape off with a plastic card to create rocky texture.

4 Remove the masking fluid with a clean finger. Add ripples using the medium detail brush and a strong mix of ultramarine and midnight green. The ripples should be bolder in the foreground to create perspective.

5 Add a touch of cobalt blue in the surf to suggest shading.

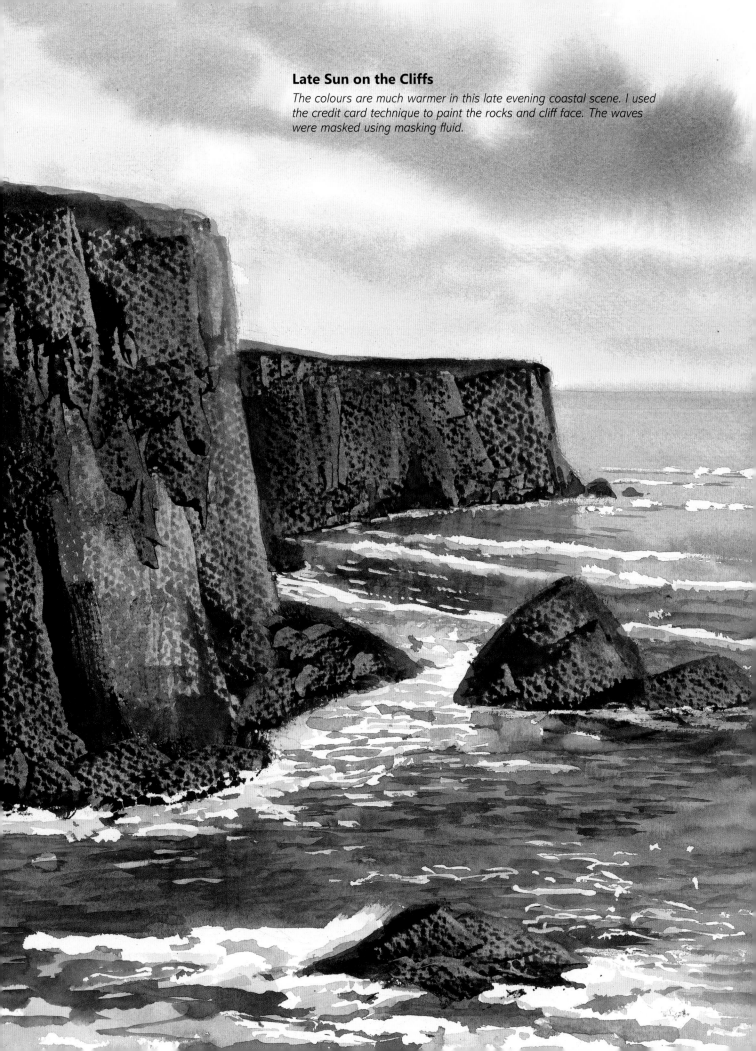

Late Sun on the Cliffs
The colours are much warmer in this late evening coastal scene. I used the credit card technique to paint the rocks and cliff face. The waves were masked using masking fluid.

A lighthouse

This step-by-step demonstration illustrates how versatile masking fluid can be. With little effort, you can create a dramatic transformation in your painting.

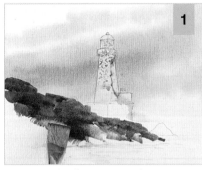

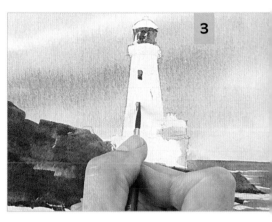

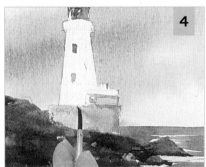

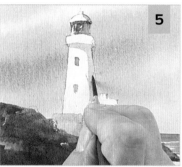

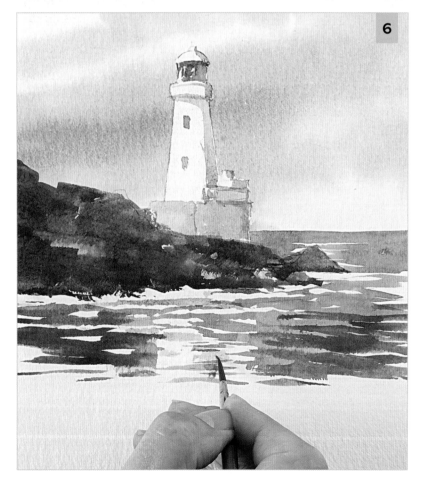

1 Use masking fluid to mask the lighthouse tower and the water where it meets the rock. Paint the sky (see Painting skies from page 34), going over the masked lighthouse. Use the 19mm (¾in) flat brush and a mix of ultramarine and burnt umber to paint the rocks.

2 Paint the sea with ultramarine and midnight green. Use a side-to-side motion to create ripples. Use a greener mix towards the foreground. Allow to dry.

3 Remove the masking fluid by rubbing with clean fingers. Take the small detail brush and a bluey mix of ultramarine and burnt umber and add details to the lighthouse.

4 Shadow the right-hand side of the lighthouse base using a mix of raw sienna and cobalt blue. Then add raw sienna to the left-hand side and texture it using the shadow mix.

5 Add shadow to the right-hand side of the lighthouse using cobalt blue.

6 Add cobalt blue ripples in the water to finish the painting.

Boats

The key to painting boats successfully is to be very precise. They are not difficult, but you do need to draw what you see – not what you think you see! The example shown here relies heavily on the effect of the dark, shady sides of the boats.

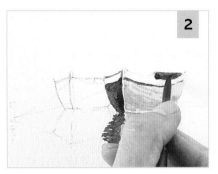
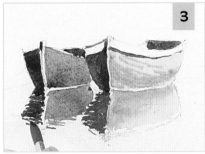
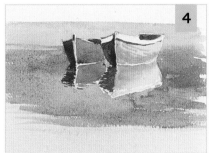
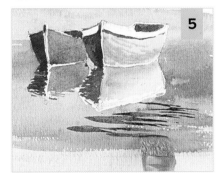
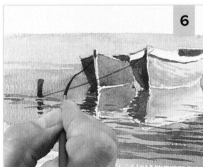

1 Use the medium detail brush and raw sienna to paint the right-hand side of the boat on the right. Then add detail using a thin mix of burnt umber. Paint the reflection in the same way, with raw sienna and then burnt umber.

2 Paint the dark part of the boat and its reflection using ultramarine and burnt umber. Next paint the shadow inside the boat.

3 Paint the other boat and its reflection with burnt sienna and burnt umber, then burnt umber and ultramarine for the dark side.

4 Use the large detail brush and a very thin mix of ultramarine to paint the background sea up to the boats. Paint a stronger mix coming further forwards and allow the painting to dry.

5 Use the 19mm (¾in) flat brush and midnight green with ultramarine to paint ripples.

6 Paint the pole sticking out of the water using the small detail brush with burnt umber and ultramarine. Change to the half-rigger brush to paint the ropes.

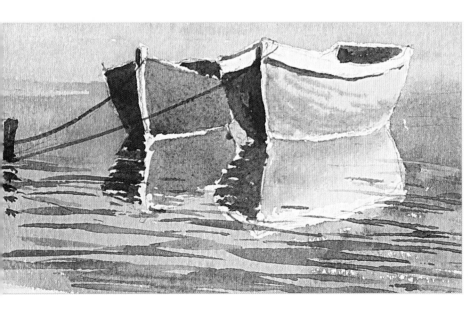

The finished boats.

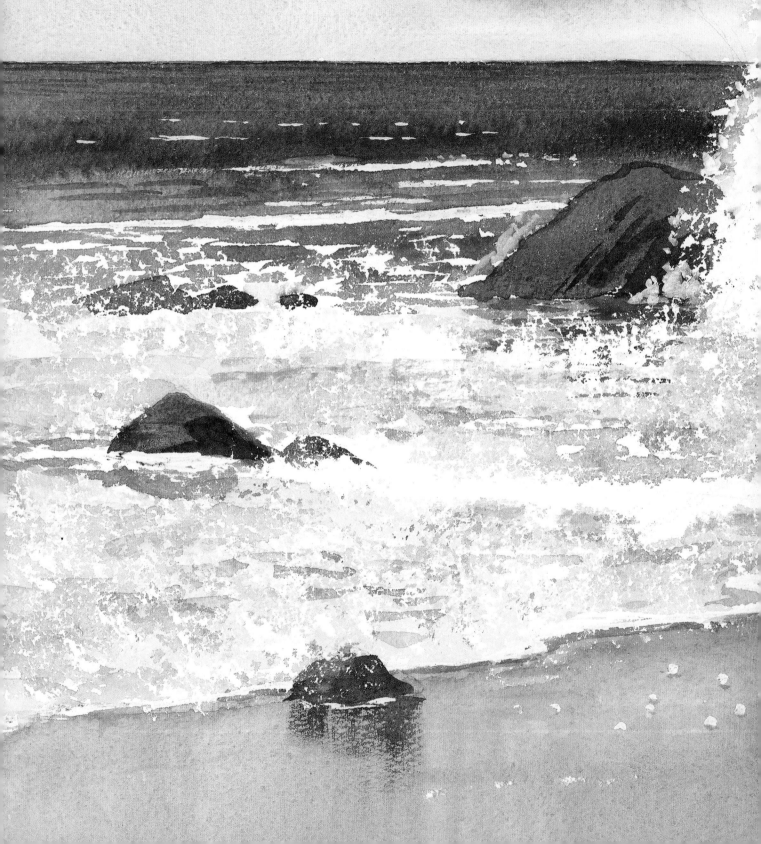

Projects

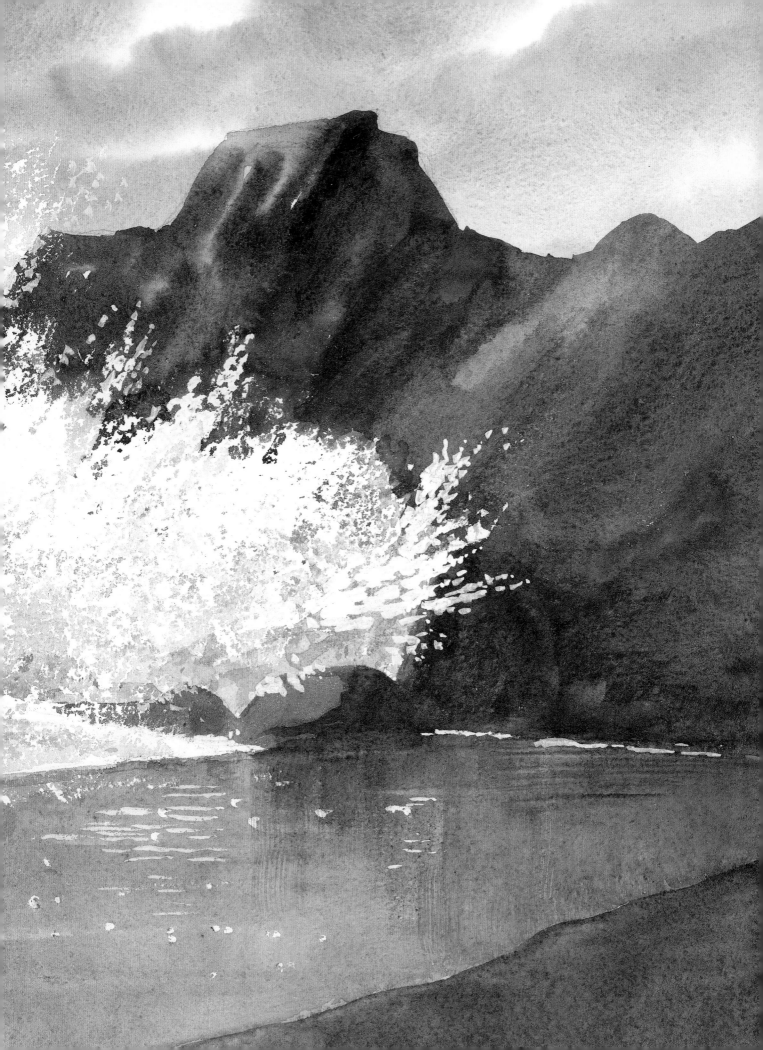

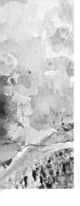

Crashing Waves

This shoreline drama of crashing waves on rugged rocks is played out most days – some days with more gusto than others. This demonstration captures that moment when the wave smashes into the solid, immovable rocks on the foreshore, pushing the spray high into the sky.

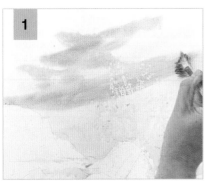

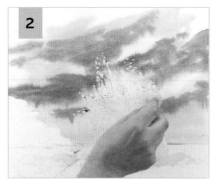

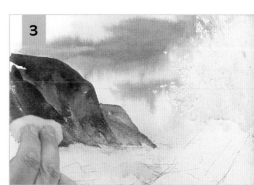

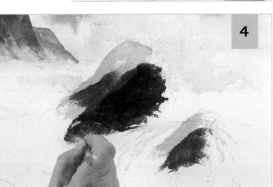

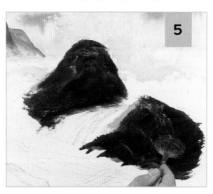

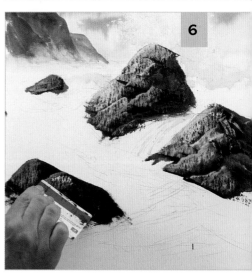

1 Use masking fluid to mask the foam burst and the rivulets of water running off rocks. Wet the sky area with the golden leaf brush and clean water, then apply a wash of raw sienna. Paint ultramarine in sweeping, diagonal strokes across the sky.

2 Paint clouds using ultramarine and burnt umber, brushing across the masked foam burst. Use a damp sponge to remove paint around the foam burst. Allow the painting to dry.

3 Paint in the headland with the large detail brush and ultramarine with burnt umber. Use a clean, damp sponge to lift out paint at the base of the headland, suggesting a sea mist.

4 Use the fan stippler and thick raw sienna to paint the sunlit sides of the rocks. Paint burnt umber on top, then ultramarine on top of that.

5 Paint a mix of ultramarine and burnt umber on top.

6 Scrape out the shape of the rocks using a plastic card. Mix ultramarine and burnt umber to paint the other rocks and scrape out texture in the same way.

7 Take the large detail brush and paint the sea with side-to-side strokes to suggest ripples. Use a ruler to help you paint a straight horizon. Continue painting the sea with ultramarine and midnight green as you come forwards.

8 Use the 19mm (¾in) flat brush and a thin wash of sunlit green to paint ripples. Add cobalt green ripples in the same way. Add cobalt blue ripples towards the foreground.

9 Paint cobalt blue and burnt umber over the masking fluid where water flows between the rocks.

10 Paint midnight green streaks across the waves. Add larger ripples in the foreground with a mix of midnight green and ultramarine. Paint round the distant rock with the same colour mix, then add very dark ripples of midnight green and ultramarine in the foreground.

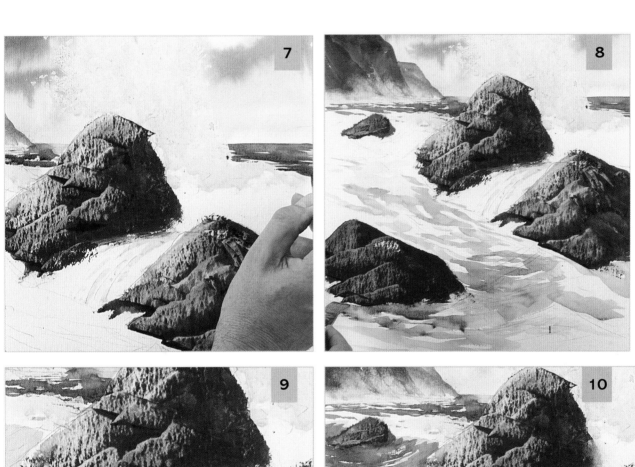

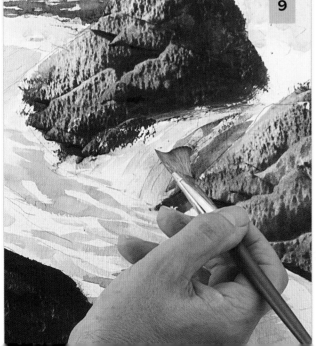

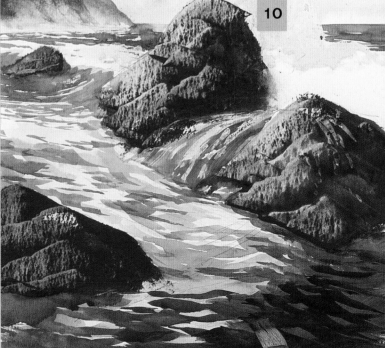

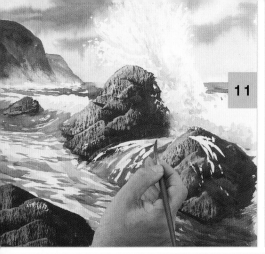
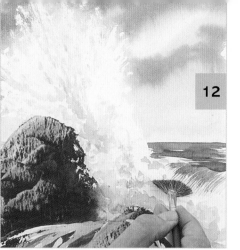

11 Rub off the masking fluid with clean fingers. Use the medium detail brush and a thin mix of cobalt blue to paint shading on the foam. Push the brush in the direction of the foam burst. Shade the rivulets of water between the rocks in the same way.

12 Use the fan gogh brush and a mix of midnight green and ultramarine to paint the crest of the wave behind the foam burst.

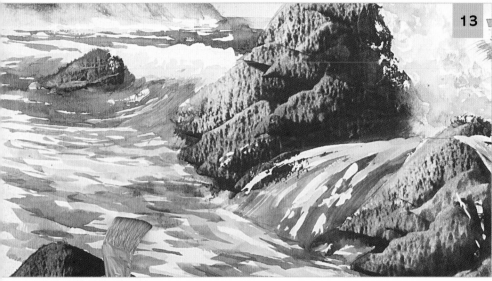

13 Take the 19mm (¾in) flat brush and paint a cadmium yellow and sunlit green mix over the water on the left of the rocks. Paint over this mix wet into wet with a wash of cobalt green.

14 Pick up a little white gouache on the medium detail brush and tidy up the rivulets between the rocks.

15 Mix cobalt blue and midnight green and darken under the breaking waves.

16 Use the medium detail brush and a little white gouache to add detail to the spray in the distance.

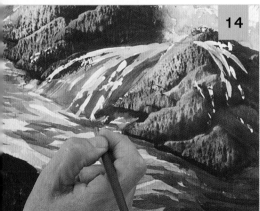
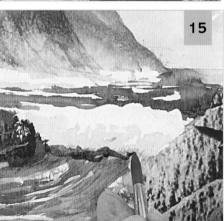

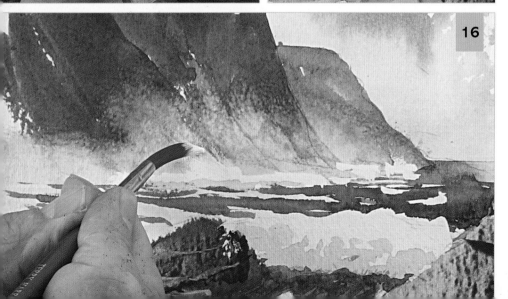

Opposite

The finished painting. The detail of the rocks relies heavily on the plastic card technique and the texture of the paper. The dark, cloudy sky helps to accentuate the light of the sea spray, preserved by masking fluid.

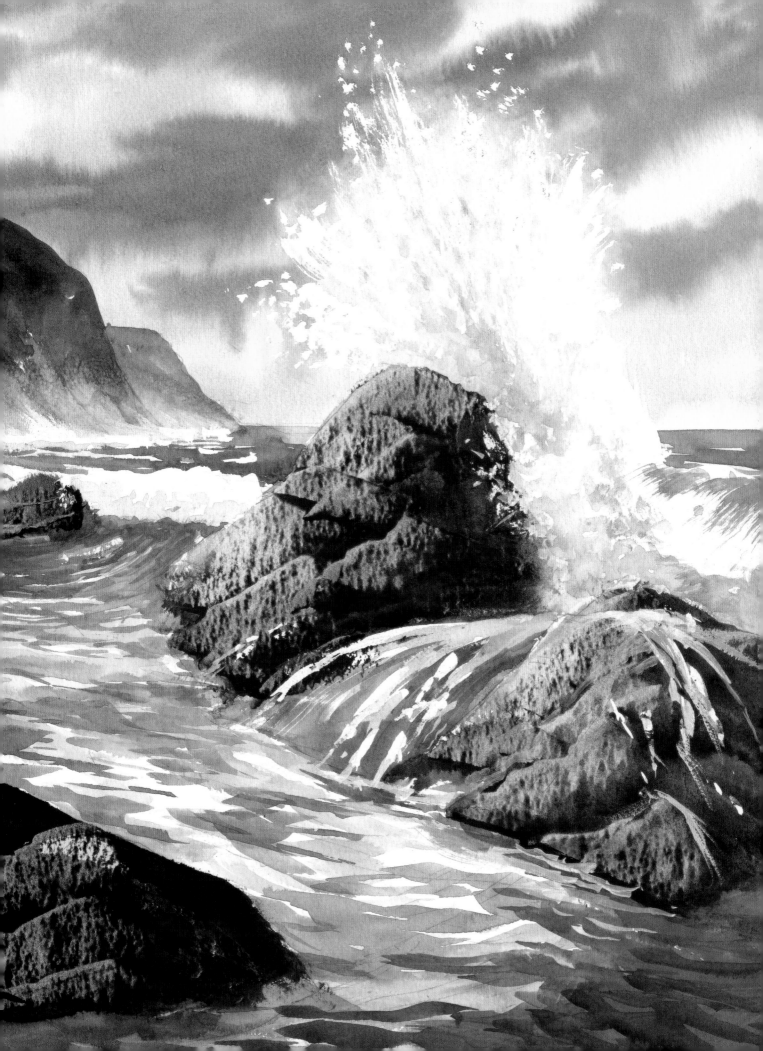

Coastal Footpath

This demonstration uses the foreground to lead you into the painting, and to add colour and interest to the picture. The path takes you round into the bay, and the sweep of the shoreline brings you out to the headland, then the clouds lead you back in the opposite direction, creating a dramatic, zigzagging composition.

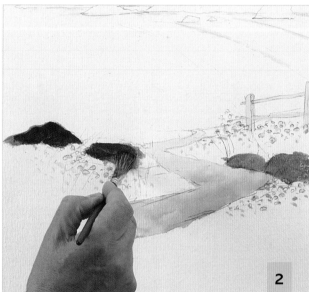

1 Use masking fluid to mask the flower heads, the fence and the edges of the water. Wet the sky area using clean water and the golden leaf brush. Paint cloud shapes with ultramarine. Mix ultramarine and burnt umber and paint dark shadows under the white of the clouds, wet into wet.

2 Take the wizard brush and paint the footpath with raw sienna. Make the colour pale towards the sea and stronger in the foreground. Paint the rocks with a thick mix of raw sienna, then apply a thick mix of burnt umber and ultramarine on top.

3 Scrape out the texture of the rocks using a plastic card.

4 Use the fan gogh brush and sunlit green paint to flick up grasses.

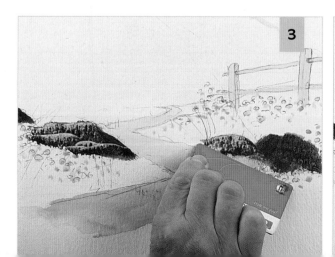

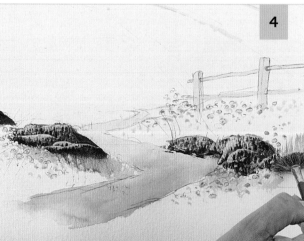

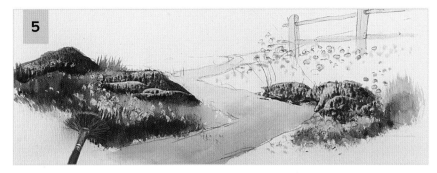

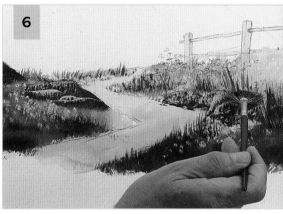

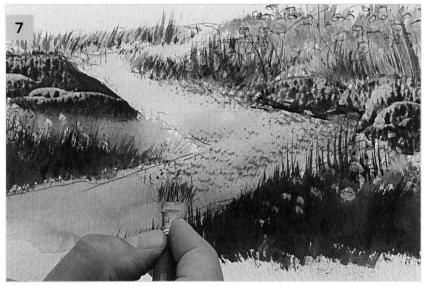

5 Add burnt sienna to the grassy area, wet into wet. Still working wet into wet, paint more grasses using country olive.

6 Paint the area nearest the fence using country olive and raw sienna. Allow to dry. Flick up more grasses using the fan gogh brush, painting wet on dry.

7 Using the foliage brush, stipple a mix of raw sienna and burnt umber on to the footpath.

8 Use the large detail brush and ultramarine with a touch of burnt umber to paint the distant headland. Paint the next hill coming forwards with a stronger mix. Mix raw sienna with ultramarine to make a warmer mix and paint the next hill coming forwards.

9 Drop in a darker mix of ultramarine and burnt umber wet into wet.

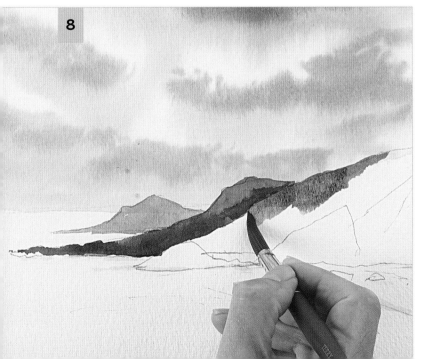

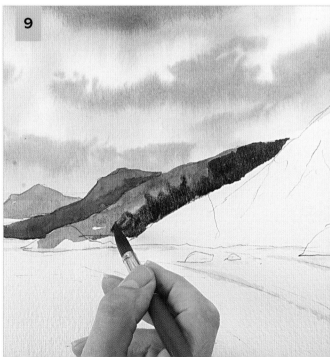

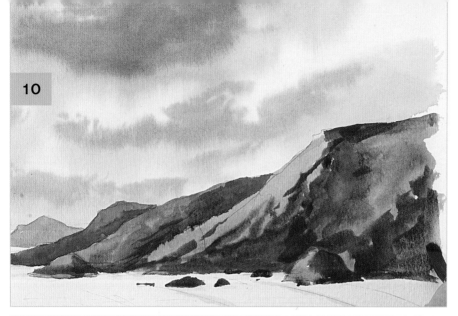

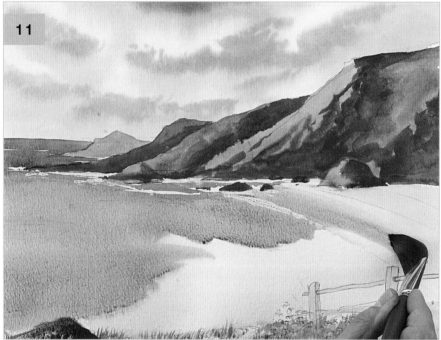

10 Paint the next hill forwards with raw sienna, then drop in ultramarine and burnt umber wet into wet to suggest crevices. Paint the smaller rock on the beach in the same way. Paint the nearest part of the rocks with ultramarine and burnt umber and leave the painting to dry.

11 Wet the beach and sea area with the Emperor extra large brush and clean water. Paint on a thin wash of raw sienna for sand. Use the same brush and ultramarine and midnight green to begin painting the sea. Add more ultramarine to the mix as you come further forwards, painting wet into wet.

12 Drop in a stronger, greener mix wet into wet. Paint lines of the greener mix to suggest waves coming in to the shore.

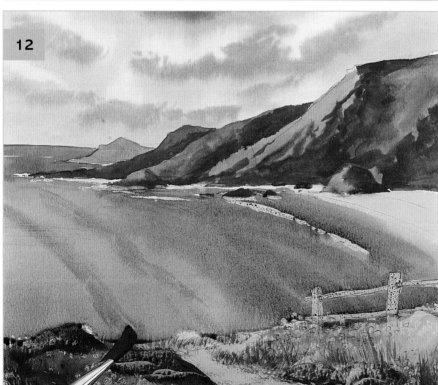

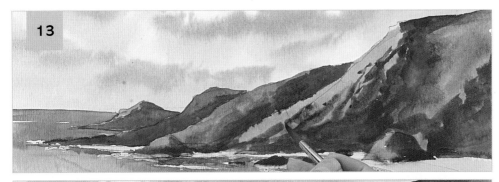

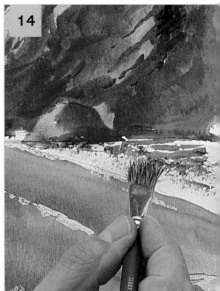

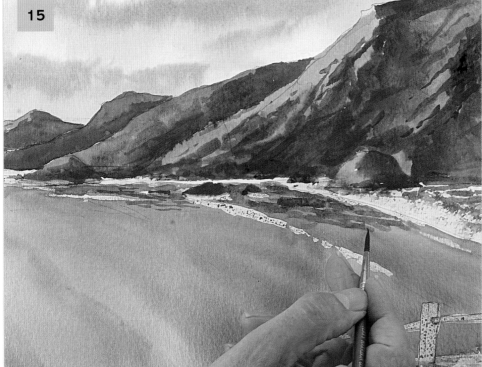

13 Take the large detail brush and darken the furthest headland with a mix of burnt umber and ultramarine. Leave it to dry. Using the medium detail brush and the colour shadow, add detail and texture to the headland.

14 Change to the foliage brush and pick up shadow to paint texture on the beach.

15 Use the small detail brush and a mix of ultramarine and midnight green to paint ripples near the shore.

16 Rub off all the masking fluid with clean fingers. Mix white gouache with a touch of cobalt blue and use the medium detail brush to add highlights to ripples coming in to shore.

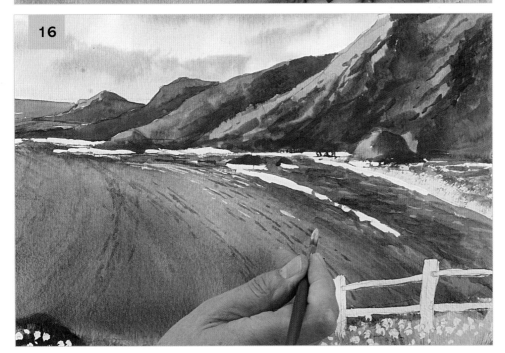

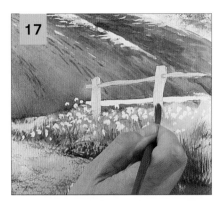

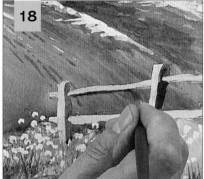

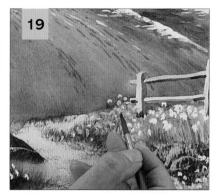

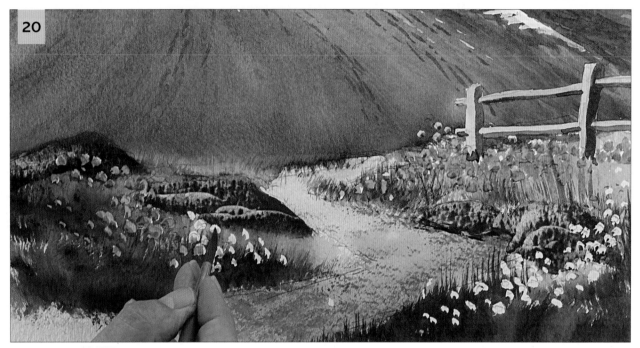

17 Paint the fence with the medium detail brush and a pale wash of raw sienna and sunlit green. Allow the painting to dry.

18 Mix country olive and burnt umber and add shading to the fence.

19 Take the small detail brush and paint a thin mix of permanent rose on the flowers.

20 Paint the flowers on the left in the same way. Then paint a stronger mix of permanent rose wet into wet. Vary the strength of the pink to create variety. Leave some flowers white, and use cobalt blue to shade others.

Opposite

The finished painting. I used a half-rigger brush to do some last minute tidying, and to paint grasses in the foreground.

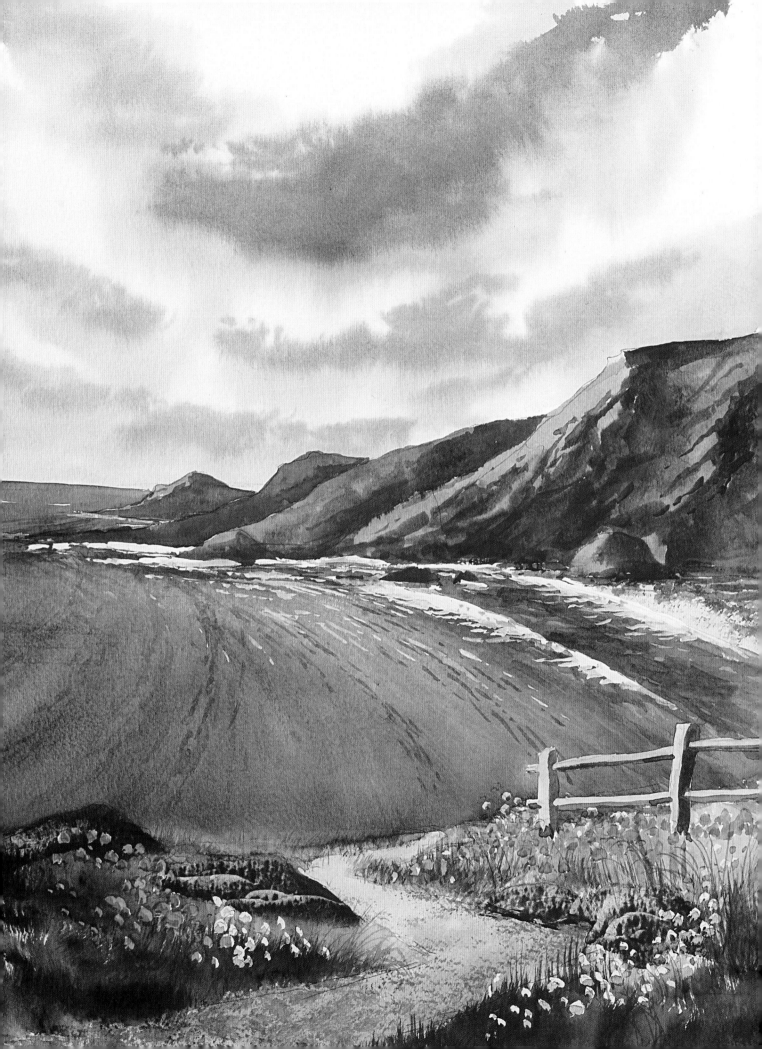

Sunset on the Sea

Watching a sunset is one of life's pleasures, and it is even better when it is setting over the sea. Capturing that moment in watercolour can only enhance that feeling. This demonstration combines a variety of techniques that you will have used earlier in the book, for example wet into wet, lifting out, using masking fluid and the plastic card technique.

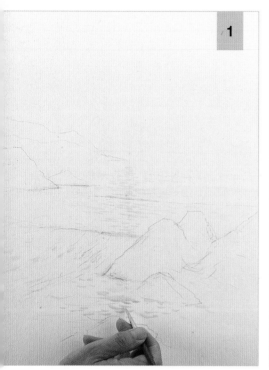

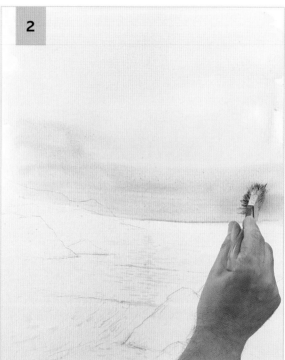

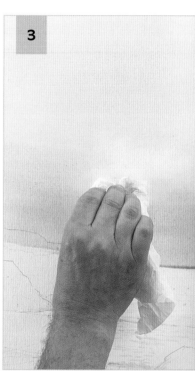

1 Draw the scene and use masking fluid and an old brush to mask off the sunlit ripples in the centre of the painting.

2 Wet the sky area with the golden leaf brush and clean water. Paint a wash of cadmium yellow across the whole sky. Working quickly wet into wet, drop in a weak mix of cadmium red from the top of the sky. Then paint a wash of cadmium red and alizarin crimson at the bottom.

3 Lift out the area where the sun shines through using a piece of kitchen paper.

4 Still working wet into wet, paint cloud shapes using the colour shadow. The clouds will naturally have a harder-edged look where they go over the lifted out area.

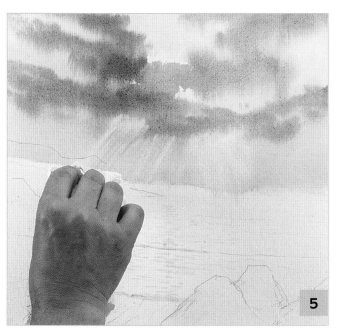 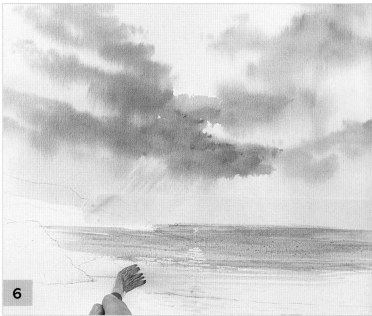

5 While the paint is still wet, take a piece of kitchen paper and lift out streaks to suggest sunlight streaming through the clouds.

6 Allow the painting to dry, then place masking tape above the line where you want the horizon to be. Use the 19mm (¾in) flat brush and a mix of cobalt blue and alizarin crimson to paint the sea up to the masking tape. Sweep from side to side to create the effect of ripples. Paint a mix of cadmium red and cadmium yellow over the top of the blue.

7 Paint with the same orangey mix over the masked area and the foreground. Lift out colour from the centre of the painting, below the sun, using kitchen paper.

8 Use the medium detail brush to paint cadmium yellow on to the foreground to strengthen the colour there. Sweep shadow colour across the horizon, towards the centre.

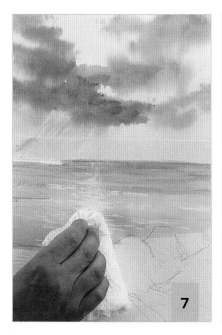 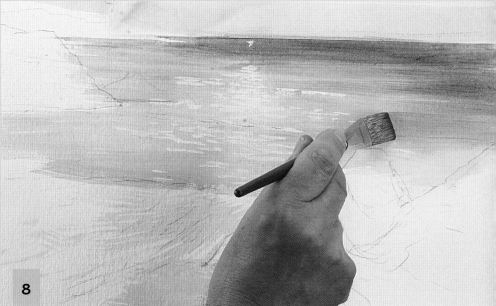

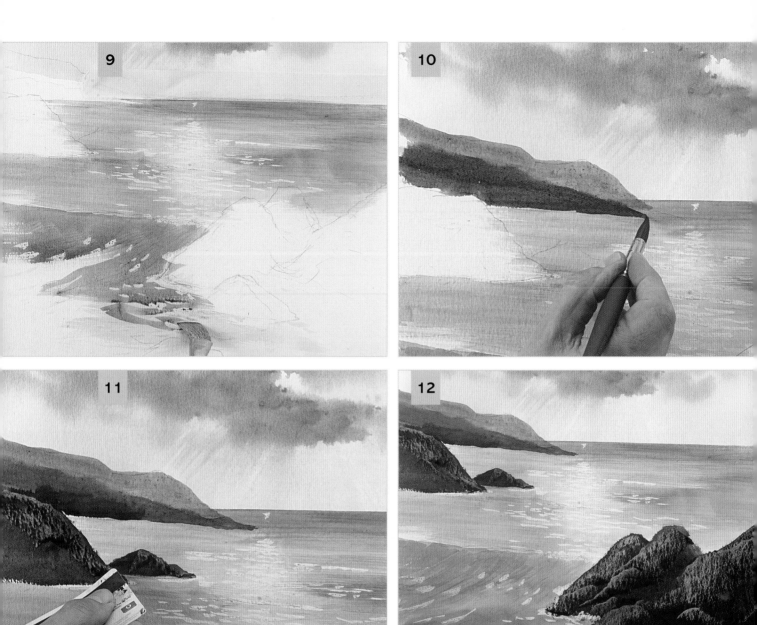

9 Sweep in more shadow colour from the left, darken the foreground in the same way and allow the painting to dry.

10 Remove the masking tape to reveal the horizon line. Use the large detail brush and a mix of burnt sienna and shadow for the distant headland. Mix burnt umber and shadow to darken the headland at the base.

11 Use a mix of ultramarine and burnt umber for the land in the middle distance. Scrape out the sunlit side of the land in the middle distance using a plastic card to create texture.

12 Make a thick mix of ultramarine and burnt umber and use the fan stippler to paint the rocks in the foreground. Scrape out the foreground rocks in the same way.

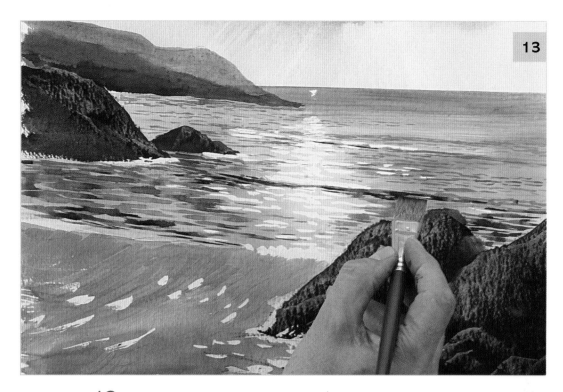

13 Rub off the masking fluid with a clean finger. Change to the small detail brush and use shadow colour to paint rippled reflections of the rocks. Continue painting ripples and shadows under the white crests of waves. Use the 19mm (¾in) flat brush to paint more ripples.

14 Darken the beach using the 19mm (¾in) brush and a mix of shadow and burnt sienna.

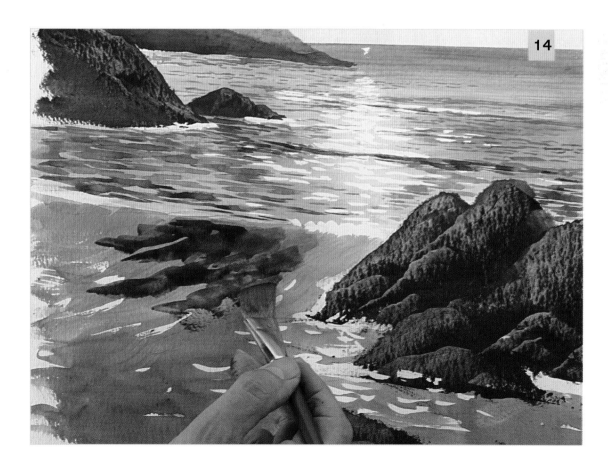

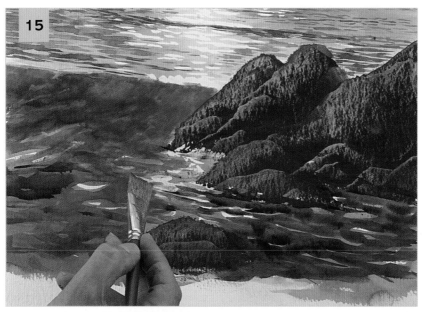

15 Mix cadmium red and cadmium yellow and paint over the dark colour of the beach, wet on dry. Add more of the same orange mix in the white ripples under the rocks.

16 Add a little cadmium red and cadmium yellow to white gouache and use the small detail brush to paint the strip of light near the horizon.

17 Use the same gouache and orange mix to paint more streaks in the water lying on the beach.

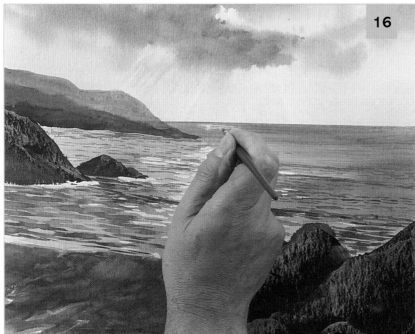

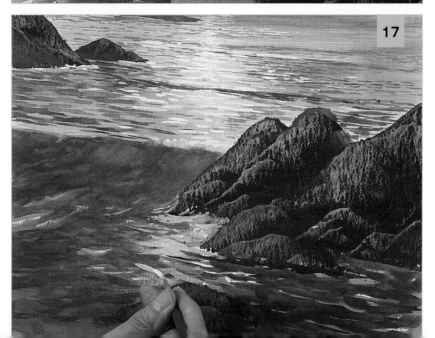

Opposite

The finished painting. After standing back to look at the painting, I noticed that the headland did not align with the horizon, so I mixed burnt umber and ultramarine to straighten it.

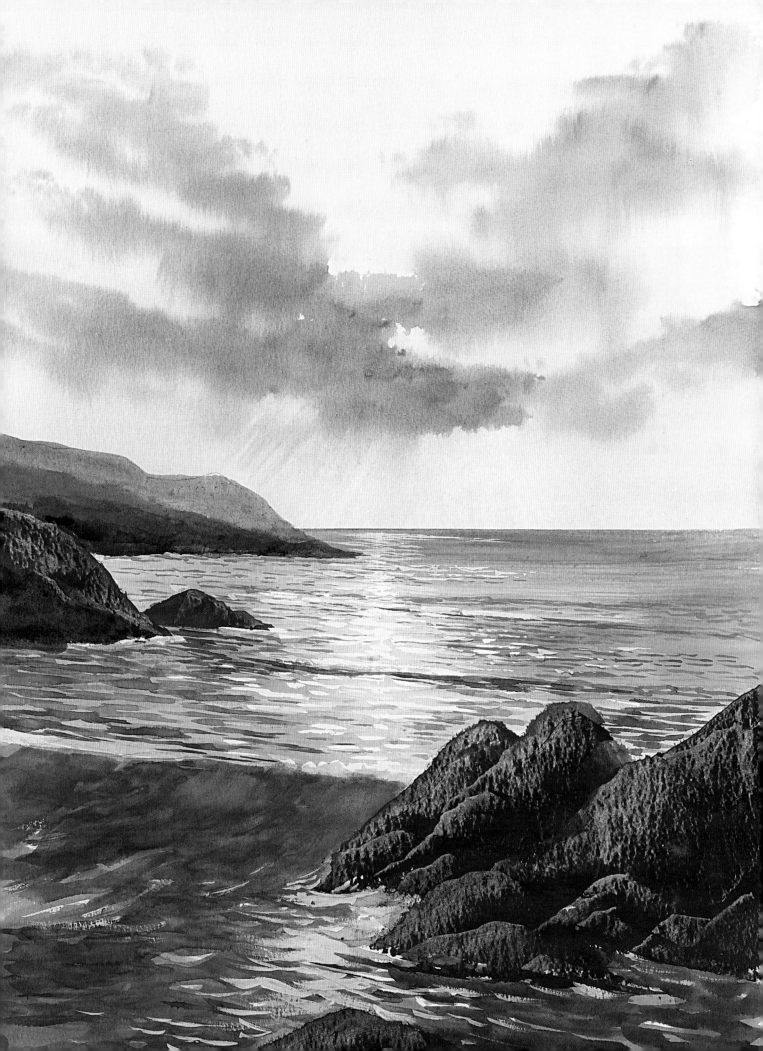

Breaking Wave

Capturing that dramatic moment when the power of the sea comes crashing onto the beach is such a thrill. The waves just keep rolling in, and every one has its own unique shape. To recreate that split second in time, I have used plenty of masking fluid to mask out the spray that shoots high in the air as the wave hits the shoreline rocks.

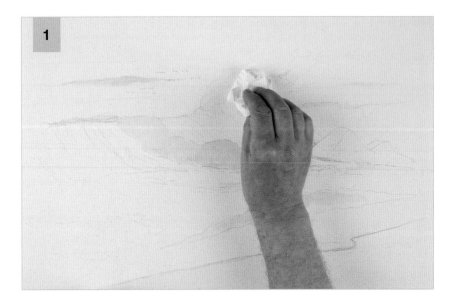

1 Draw the scene. Use an old brush to mask the crest of the wave in the distance and all the surf and foam. Then take a pad of kitchen paper, dip it in the masking fluid and pat it on to the paper to mask out the spray from the breaking wave. Allow to dry.

2 Use the plastic card technique to paint the rocks protruding from the waves (see page 44). Paint the sunlit sides first with the foliage brush and raw sienna.

3 Paint a thicker mix of country olive on top, and then a still thicker, darker mix of ultramarine and burnt umber on top of that. Take an old plastic card and scrape it over the rocks. Where you leave darker paint, crevices and shadows will appear. The textured surface of the paper will suggest the texture of the rocks. Allow to dry.

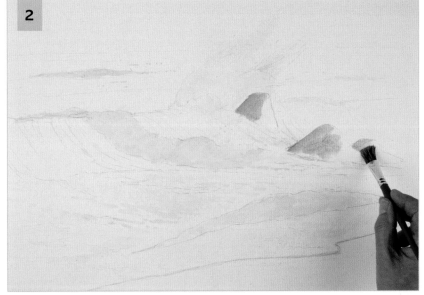

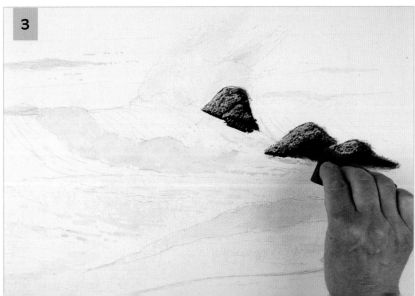

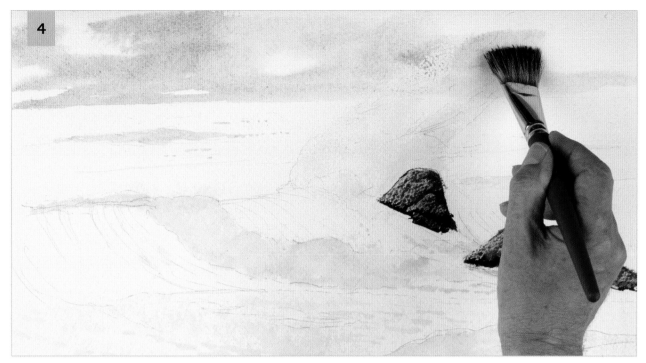

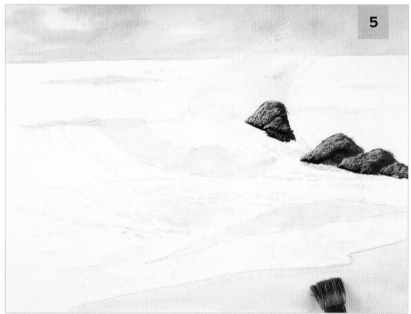

4 Wet the sky area with the golden leaf brush and clean water. Pick up a wash of ultramarine and brush it into the sky, leaving white paper for clouds.

5 Paint the beach area with a weak wash of raw sienna.

6 Make a strong mix of ultramarine and midnight green for the sea. To paint the horizon, use a ruler and the large detail brush. Place your fingers under the edge of the ruler and run the ferrule of the brush along it to ensure a straight line.

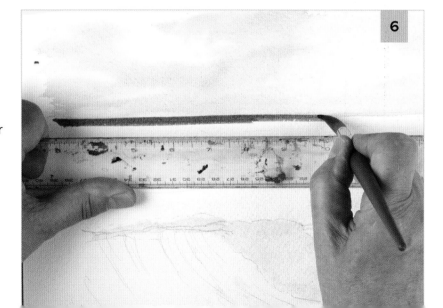

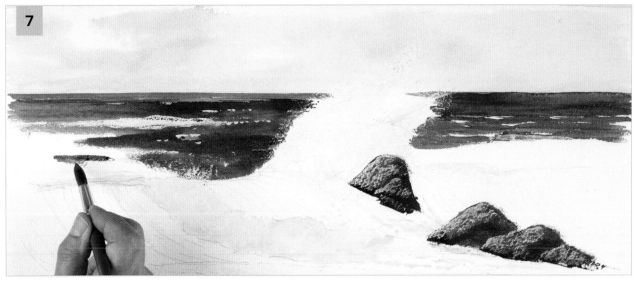

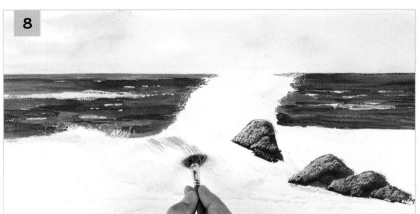

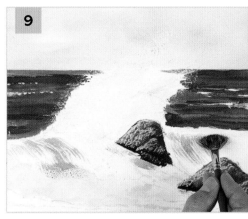

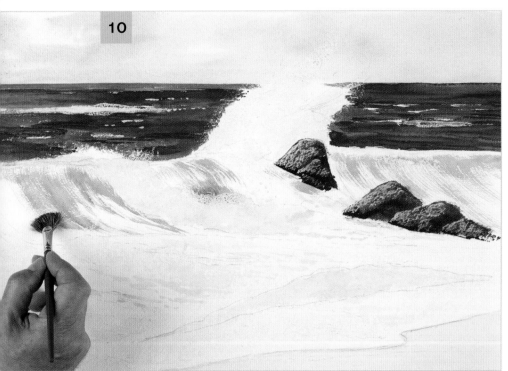

7 Continue the horizon to the right of the breaking wave, then paint further horizontal lines, leaving gaps of white paper. Add more midnight green into the mix as you come forwards.

8 Make a slightly paler mix of ultramarine, midnight green and a touch of phthalo turquoise and use the fan gogh brush to pull down textured lines to suggest a wave rolling forwards.

9 Use the same colour and brush, but brush upwards to create a rising wave on the right, just about to break.

10 Continue painting the moving water in this way.

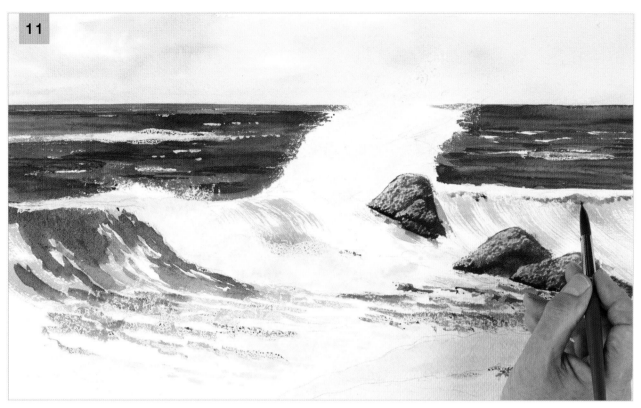

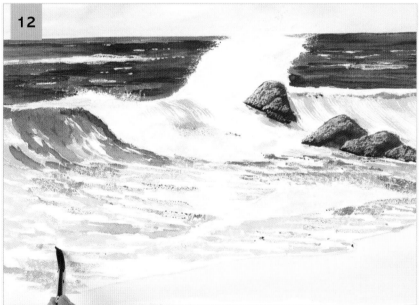

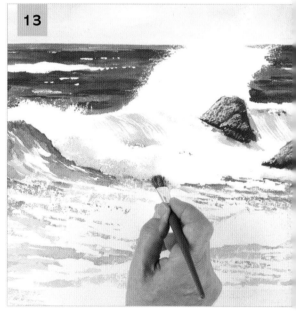

11 Make a darker mix of the same colours and use the large detail brush to paint shadowed parts of the waves, especially under the crests.

12 Use a lighter mix of the same colours to paint over the masking fluid in the surf, leaving gaps and adding shadow where required. Allow to dry.

13 Remove all the masking fluid with clean fingers. Take the foliage brush with a mix of cobalt blue and a little phthalo turquoise and stipple into the white paper area to create the shadow in the foam, giving it form.

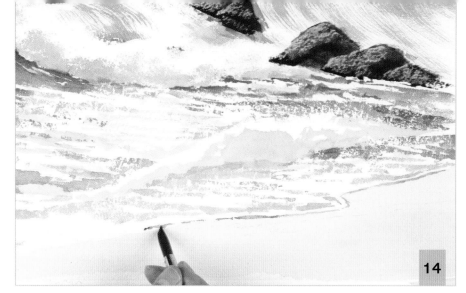

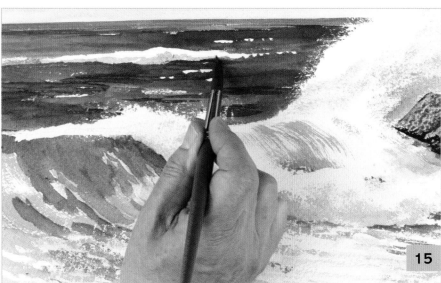

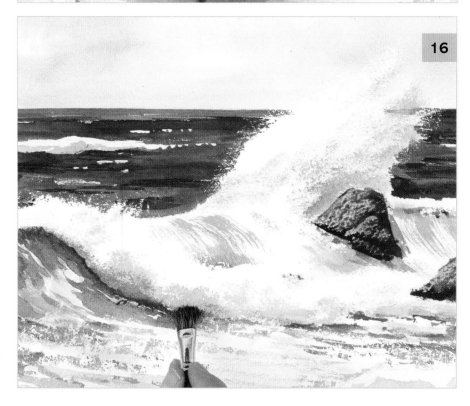

14 Paint shadow under the surfline on the beach with the same mix and the large detail brush.

15 Use the same brush and mix to paint shadow under the cresting waves in the distance.

16 Continue stippling texture into the foam burst and the edges of the breaking wave with the foliage brush and a darker mix of cobalt blue and phthalo turquoise.

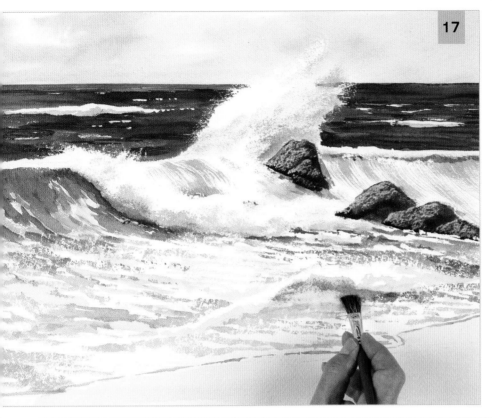

17 Add texture and shade under the breaking wave in the foreground in the same way.

18 Mix raw sienna and burnt umber and stipple texture onto the beach.

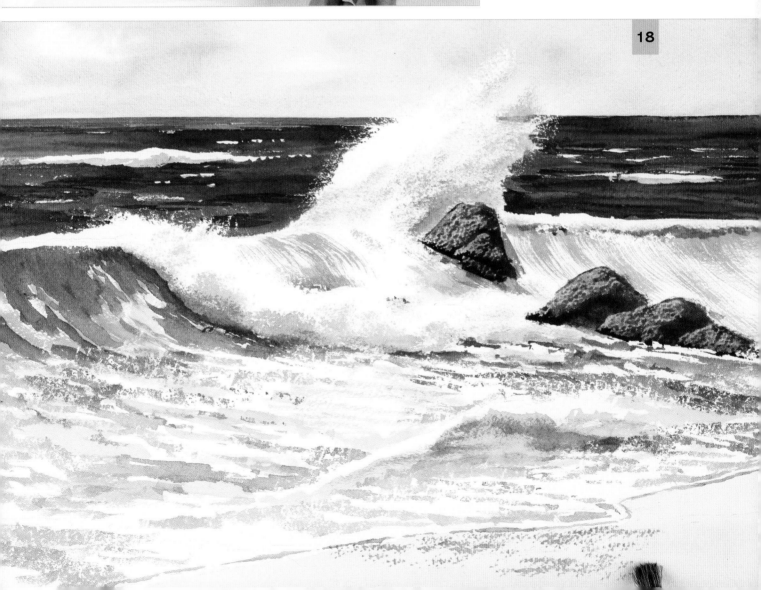

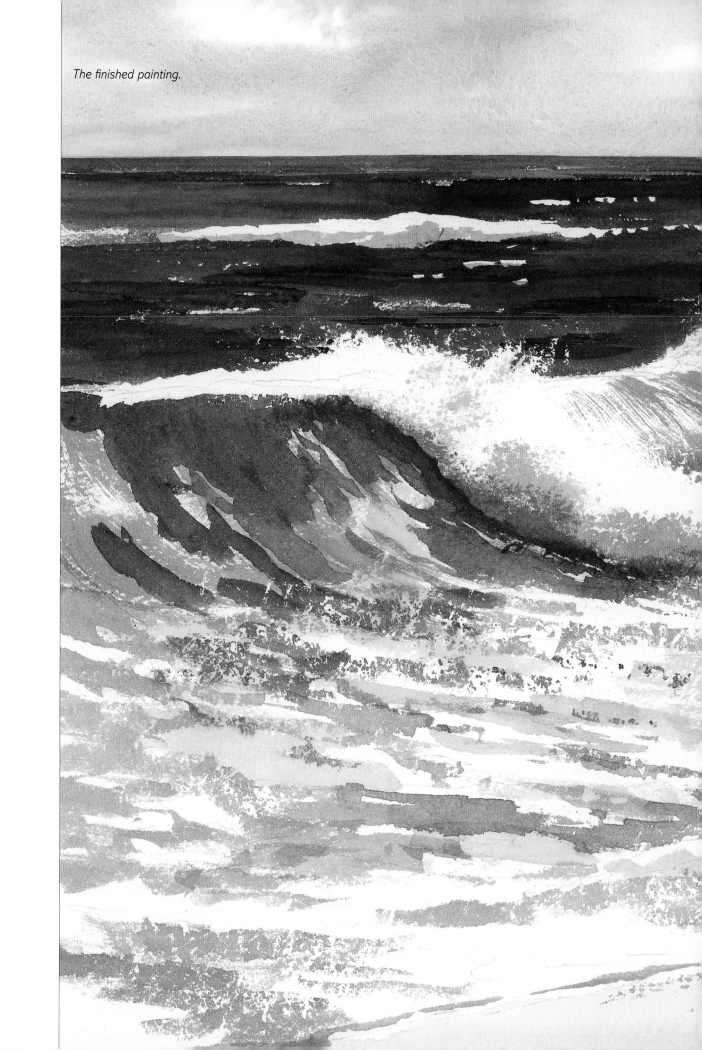

The finished painting.

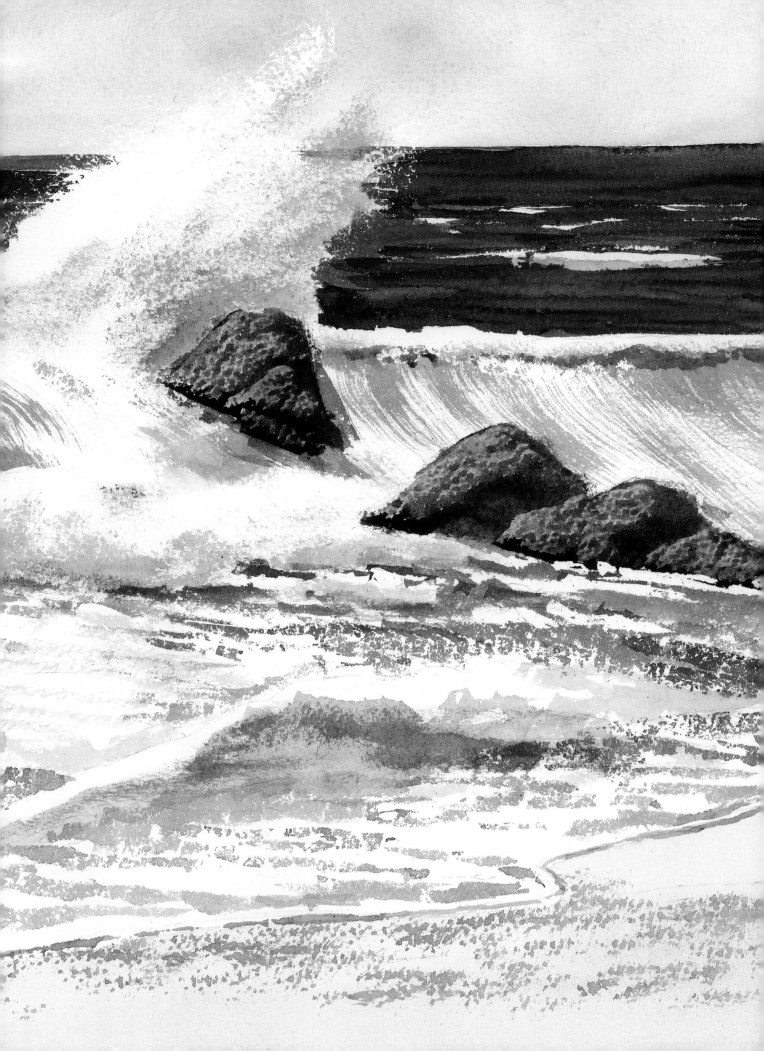

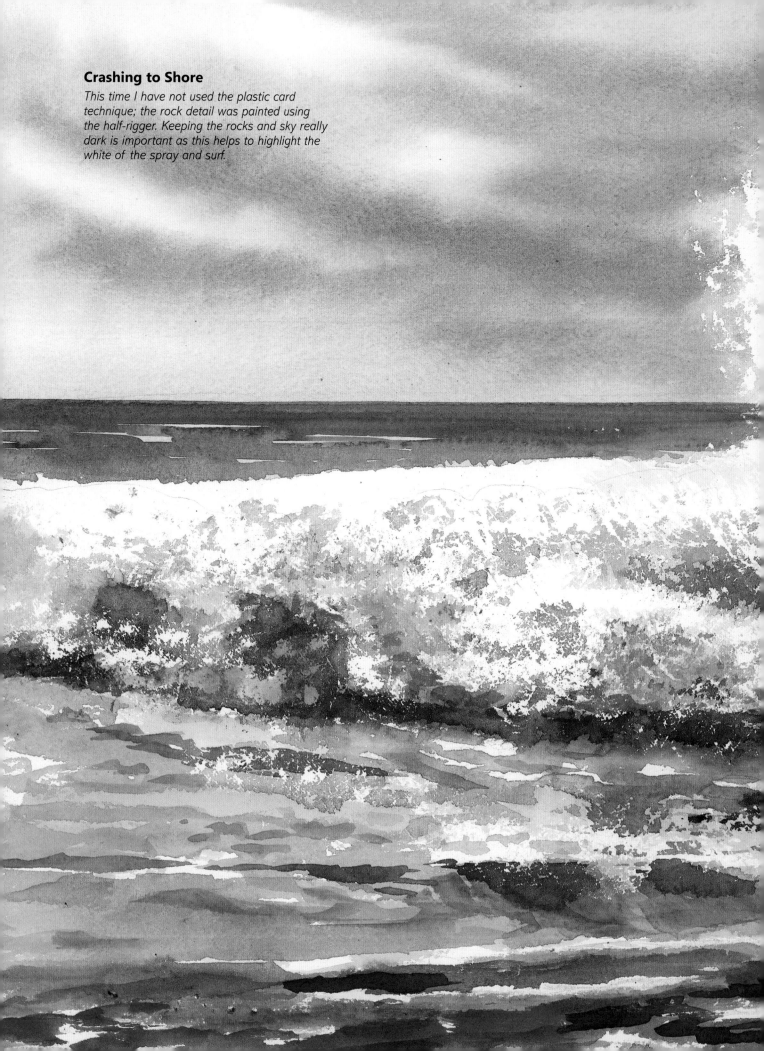

Crashing to Shore

This time I have not used the plastic card technique; the rock detail was painted using the half-rigger. Keeping the rocks and sky really dark is important as this helps to highlight the white of the spray and surf.

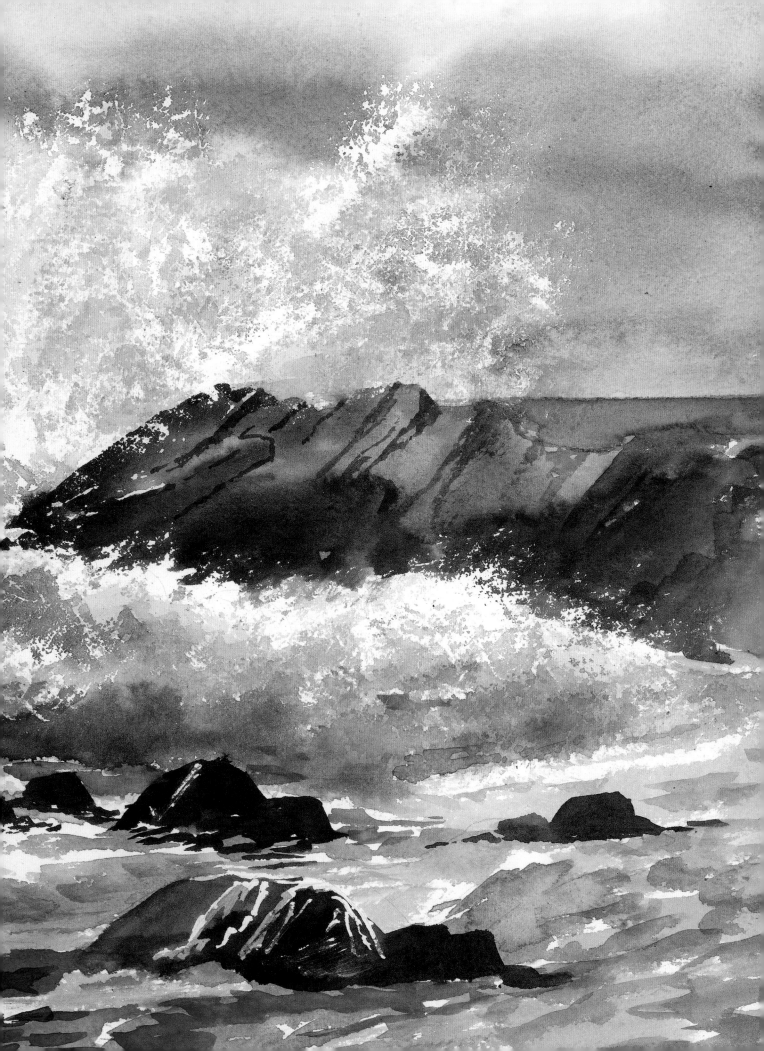

Estuary Boats

Estuaries and salt marsh flats are often quiet, still landscapes with few or no landmarks to focus on, and they provide an opportunity to paint big, dramatic skies. Here, the focal point comes in the shape of some rowing boats in the foreground, carefully positioned to lead the viewer into the painting.

1 Draw the scene and mask the edges of the boats and the sparkles in the water, using masking fluid and an old brush.

2 Wet the whole painting apart from the boats with the golden leaf brush and clean water. Sweep a pale mix of raw sienna across the lower sky and the water in broad, horizontal strokes.

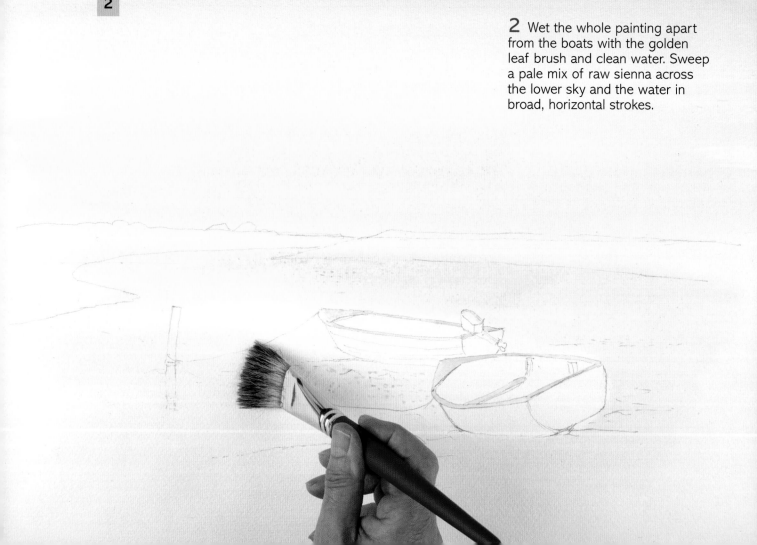

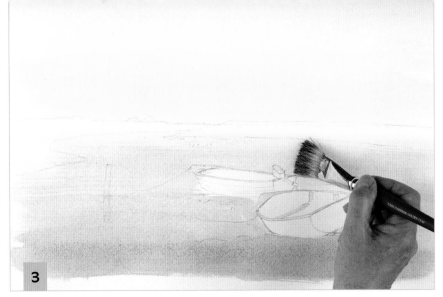

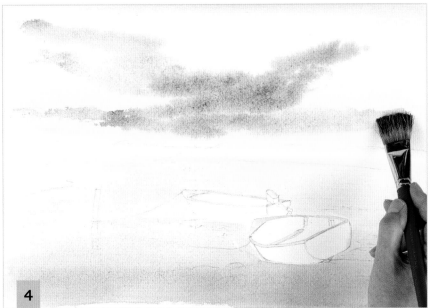

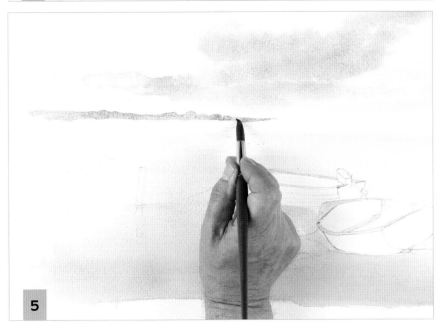

3 Make a thicker paint mix of shadow and cobalt blue and brush this in horizontal strokes across the bottom of the water, moving up into the yellow so that the purple bleeds into it and blends.

4 Use a darker mix of the same colours to brush cloud shapes into the still-wet sky.

5 Paint the distant horizon with the large detail brush and a pale mix of ultramarine and shadow.

6 Use a stronger mix of the same colours below this, then add burnt umber to the mix and paint this further forwards.

7 Paint the land on the right with the ultramarine and shadow mix, then while this is wet, drop in a thicker mix of raw sienna. This spreads and granulates, creating texture.

8 Take the large detail brush and a mix of burnt umber and country olive, and paint texture under the foreground boat, with dots and dashes of paint. Use a lighter mix and the dry brush technique around the other boat, over the masking fluid: load the brush with a thick mix without much water and drag it over the rough paper surface to create texture. Using a darker mix again, dot stones into the mud flat.

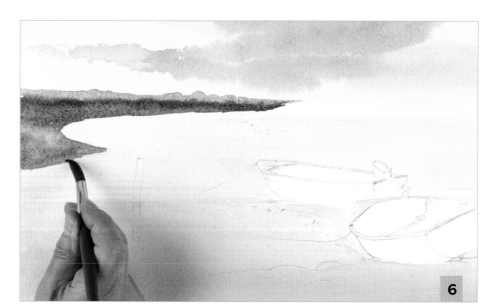

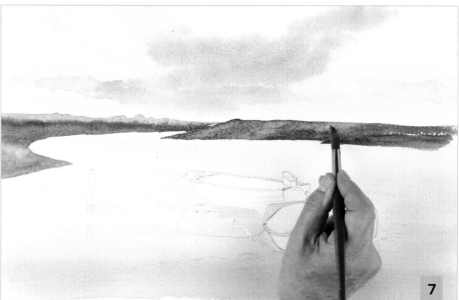

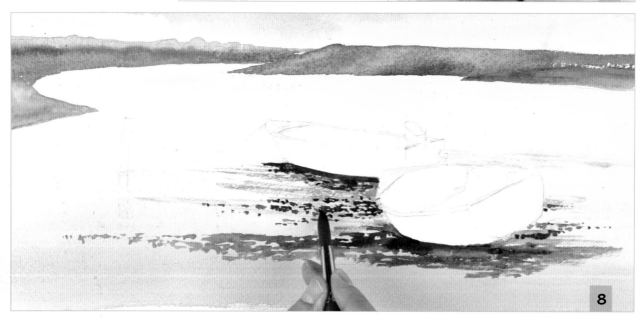

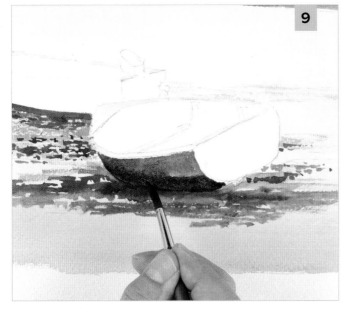

9 Change to the medium detail brush and use a mix of ultramarine and burnt umber to paint the hull of the foreground boat, making it darker at the bottom.

10 Paint the inside of the boat with a paler mix of the same colours, blending to the darker mix for shadows, to create form.

11 Darken the ultramarine and burnt umber mix still further to paint the stern of the boat, and while this is wet, drop in raw sienna wet into wet. The raw sienna will granulate and bleed into the dark blue to create texture and the impression of weathering.

12 Use a mix of burnt sienna and ultramarine to paint the inside and stern of the other boat.

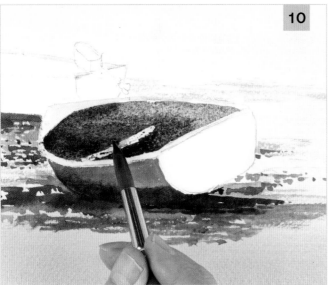

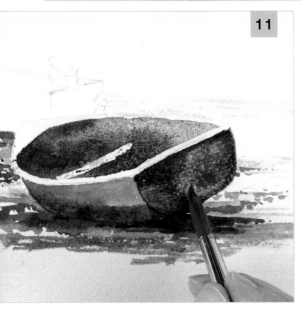

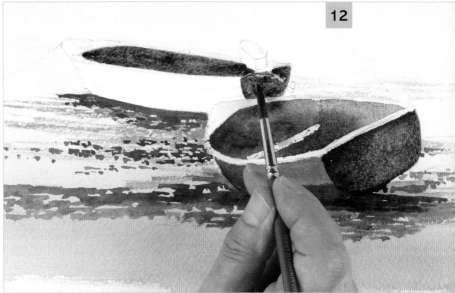

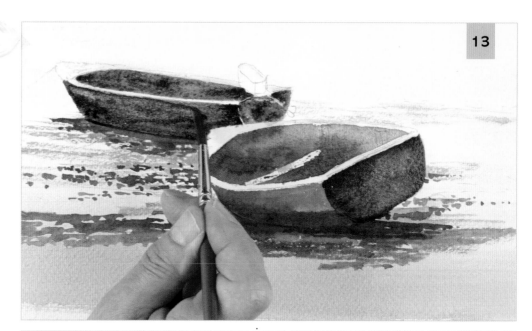

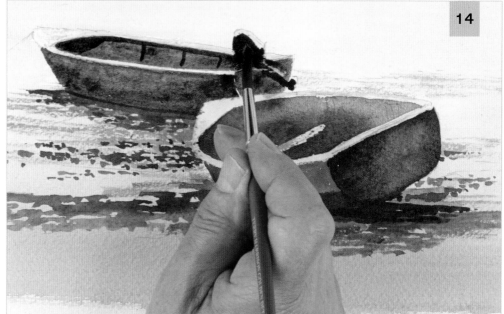

13 Paint the hull of the second boat in the same way as the first, with a dark wash of ultramarine and burnt umber, followed by raw sienna dropped in wet into wet.

14 Use a dark mix of burnt sienna and ultramarine to paint the outboard motor and other dark details of the second boat.

15 Complete the inside detail of the foreground boat with same mix, with slightly more blue.

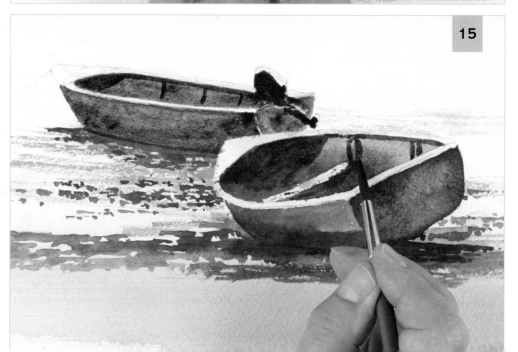

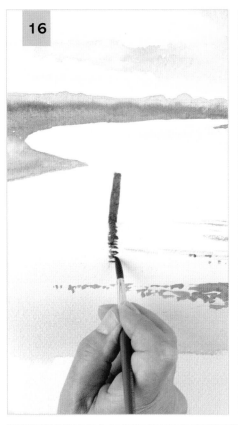

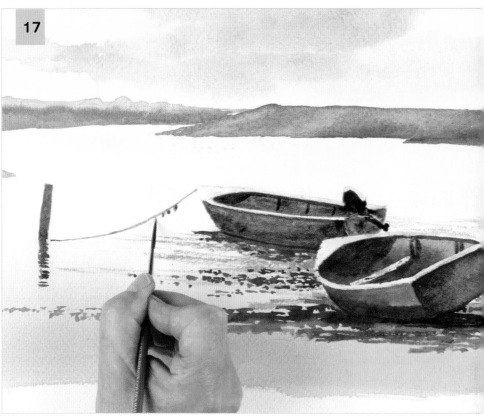

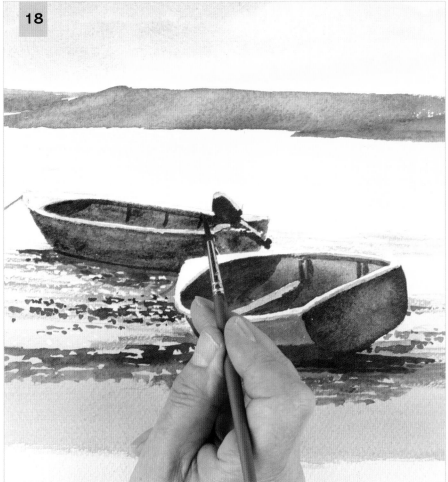

16 Mix burnt umber and country olive and paint the mooring post. Make short horizontal strokes to suggest the reflection beneath it.

17 Change to the half-rigger brush and paint the mooring rope with the same mix. Add weed hanging off the rope.

18 When the painting is dry, remove the masking fluid with clean fingers. Make a very pale mix of ultramarine and shadow, and use the small detail brush to tone down the starkness of the white paper highlights.

Overleaf
The finished painting.

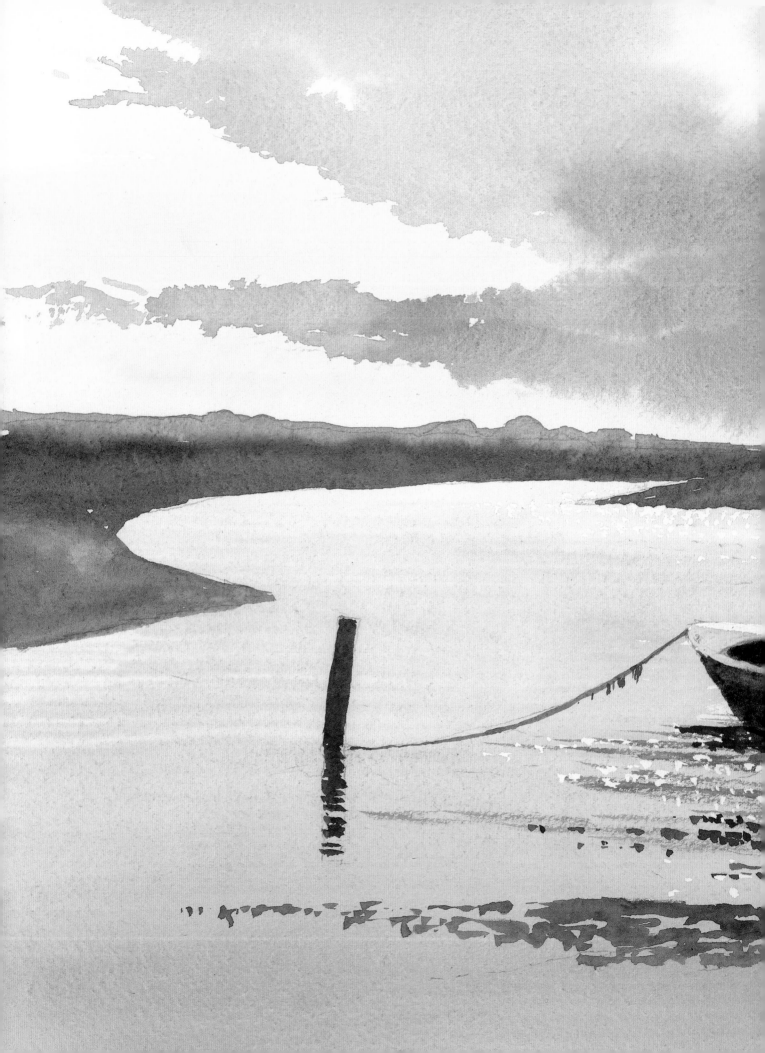

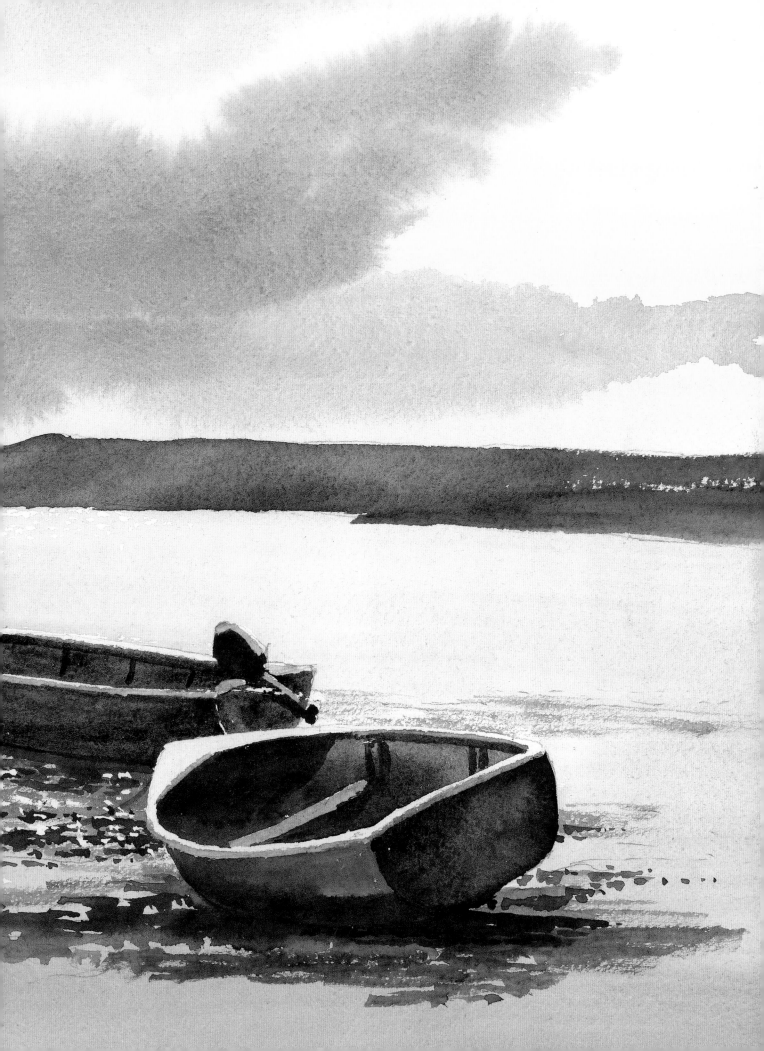

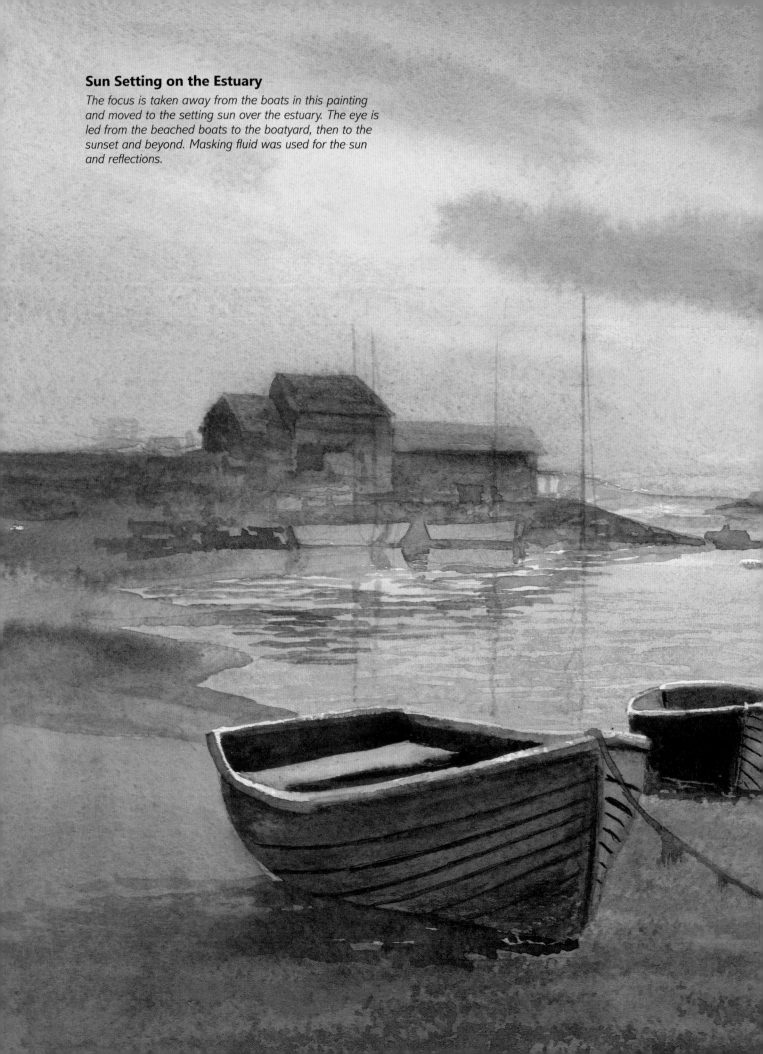

Sun Setting on the Estuary

The focus is taken away from the boats in this painting and moved to the setting sun over the estuary. The eye is led from the beached boats to the boatyard, then to the sunset and beyond. Masking fluid was used for the sun and reflections.

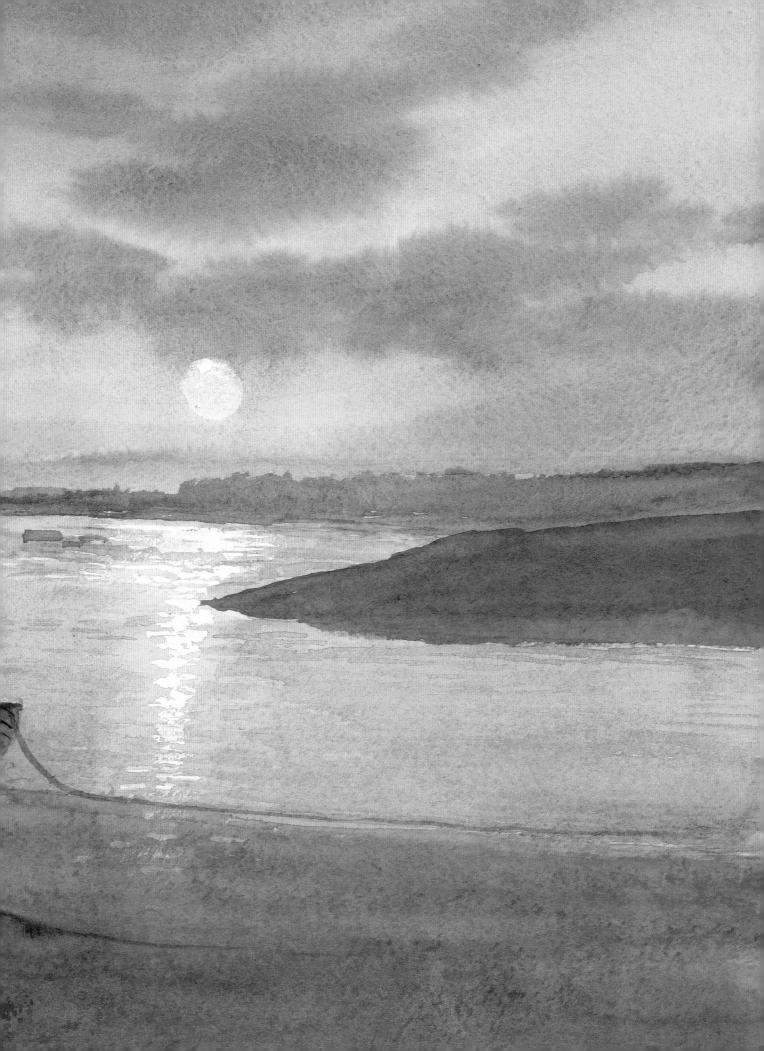

The End of the Pier

The seaside pier was a Victorian invention; you had all the thrills and excitement of going to sea, but you never left dry land. Holidaymakers could promenade overlooking the sea or even catch a show in the theatre at the end of the pier. This painting captures the pier almost in silhouette, with sunlight sparking on the water between the beach and pier.

1 Draw the scene and mask out the lightest areas of the water and the sparkles, using masking fluid and an old brush. When this is dry, take the golden leaf brush and wet the sky area with clean water. Paint a thin wash of raw sienna over the whole sky, then brush in shadow at the top in horizontal strokes, wet into wet.

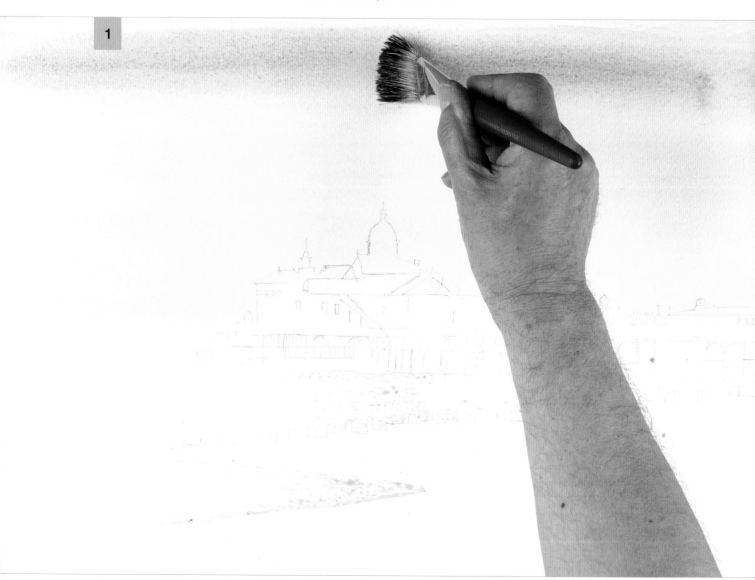

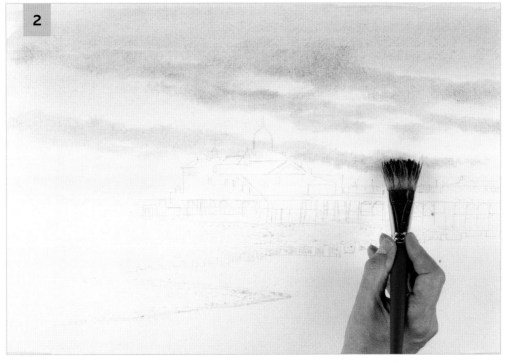

2 Mix cobalt blue and shadow and brush this mix into the wet sky to create clouds. Make them smaller lower down towards the horizon.

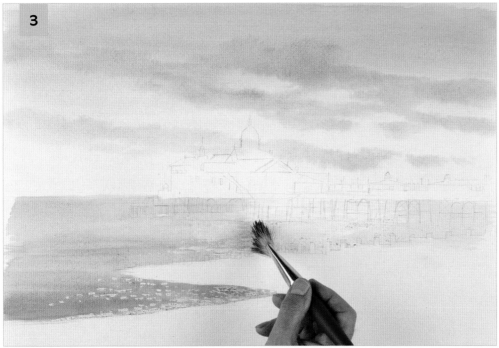

3 Sweep this mix over the water area, covering the masking.

4 Begin to paint the pier with a darker mix of the same colours, using the medium detail brush.

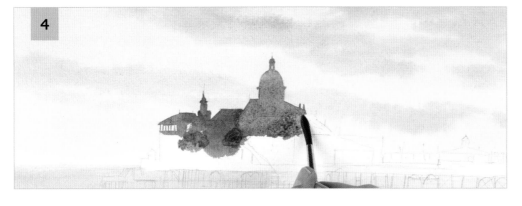

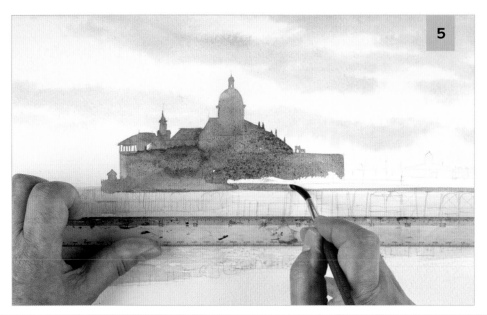

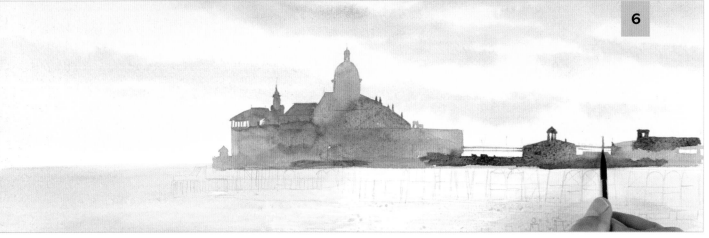

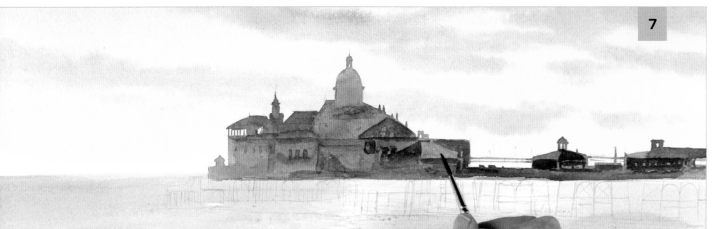

5 Use a ruler to help you paint the straight lines.

6 Continue blocking in the pier with the same mix, including the almost silhouetted shapes on the right. Allow to dry.

7 Make a darker mix of ultramarine and shadow and use the small detail brush to paint the detail over the blocked-in shape of the pier.

8 Change to the large detail brush and paint the groyne in the foreground with a mix of shadow, ultramarine and burnt umber.

9 Mix burnt sienna, shadow and ultramarine and use the golden leaf brush to paint the dark beach in the foreground. Allow to dry.

10 Use a flat 13mm (½in) synthetic brush and a mix of shadow and ultramarine to paint small horizontal strokes in the sea, suggesting rippled reflections.

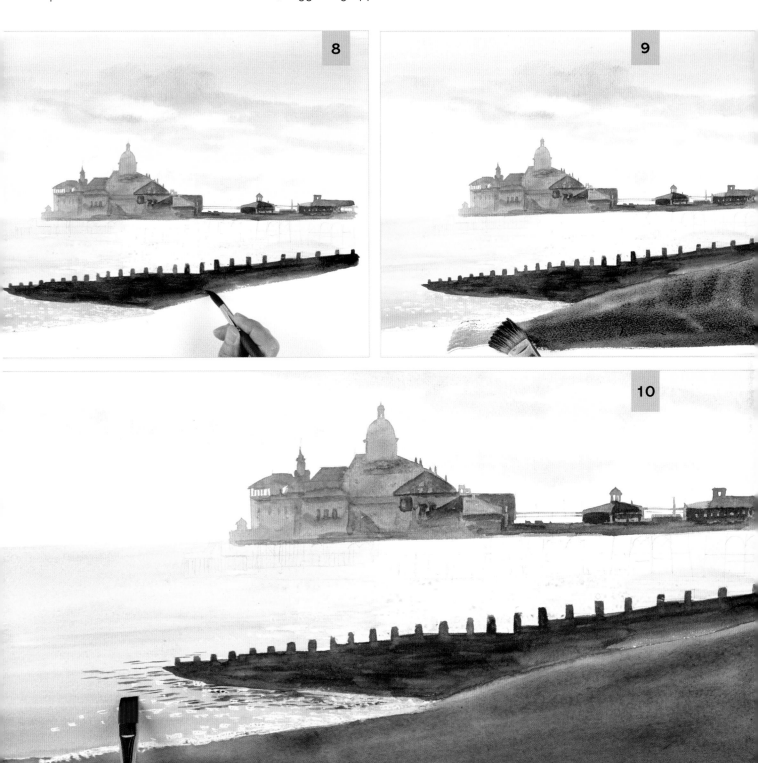

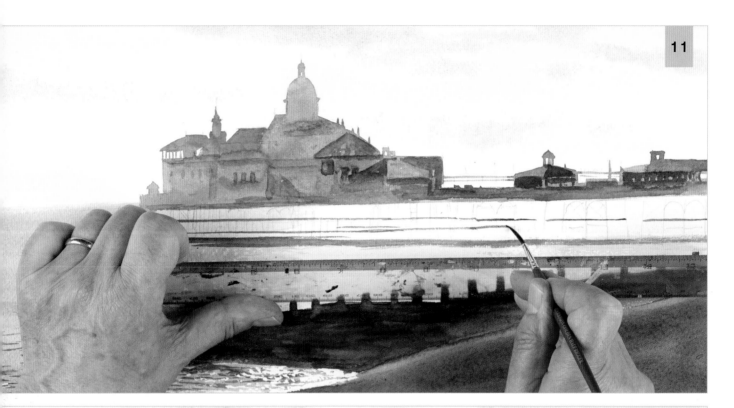

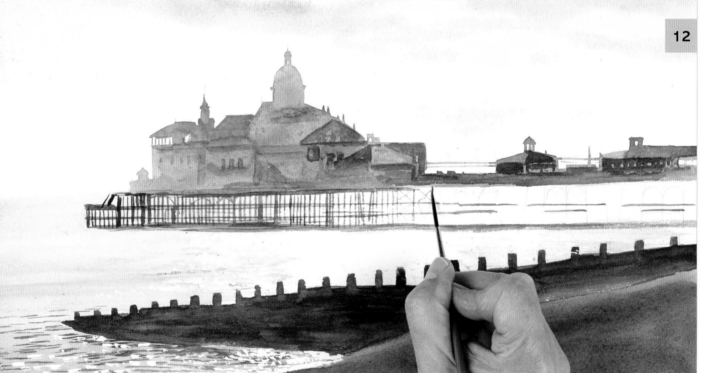

11 Allow the painting to dry and remove the masking fluid. Tidy the edges if necessary. Use a half-rigger brush and a mix of ultramarine and shadow to paint the horizontal lines of the pier. Use a ruler to help you.

12 Continue creating the structure of the pier, painting the vertical lines and other details.

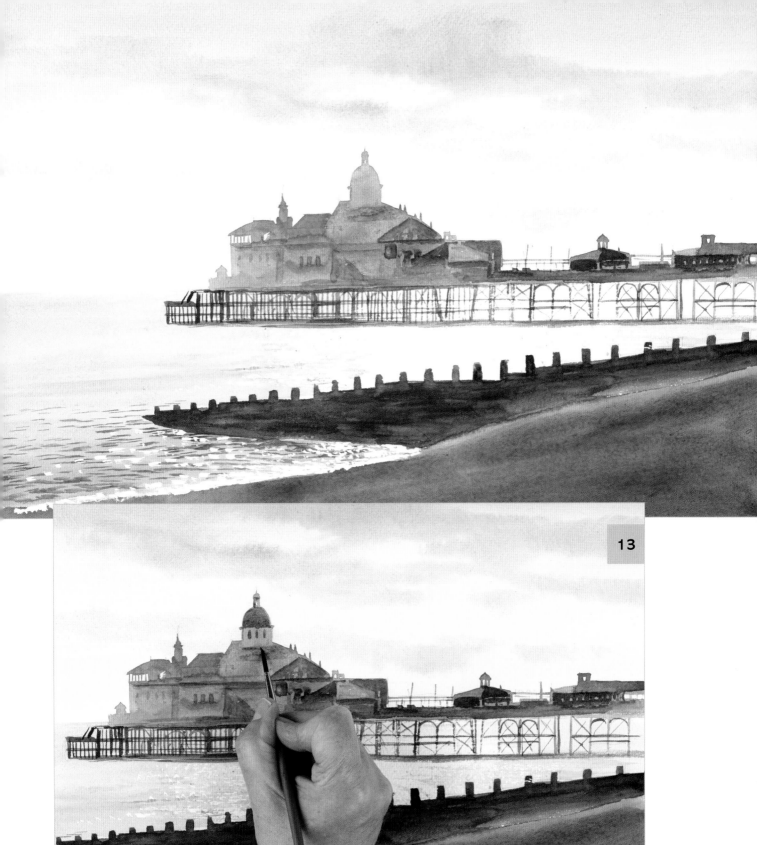

13 At this point, stand back from the painting and decide if there is anything more you need to add. After looking at the painting (top image), I decided that the dome needed to be darker. I used the medium detail brush and a mix of cobalt blue and shadow to darken it, and added darker detail to the buildings on the end of the pier.

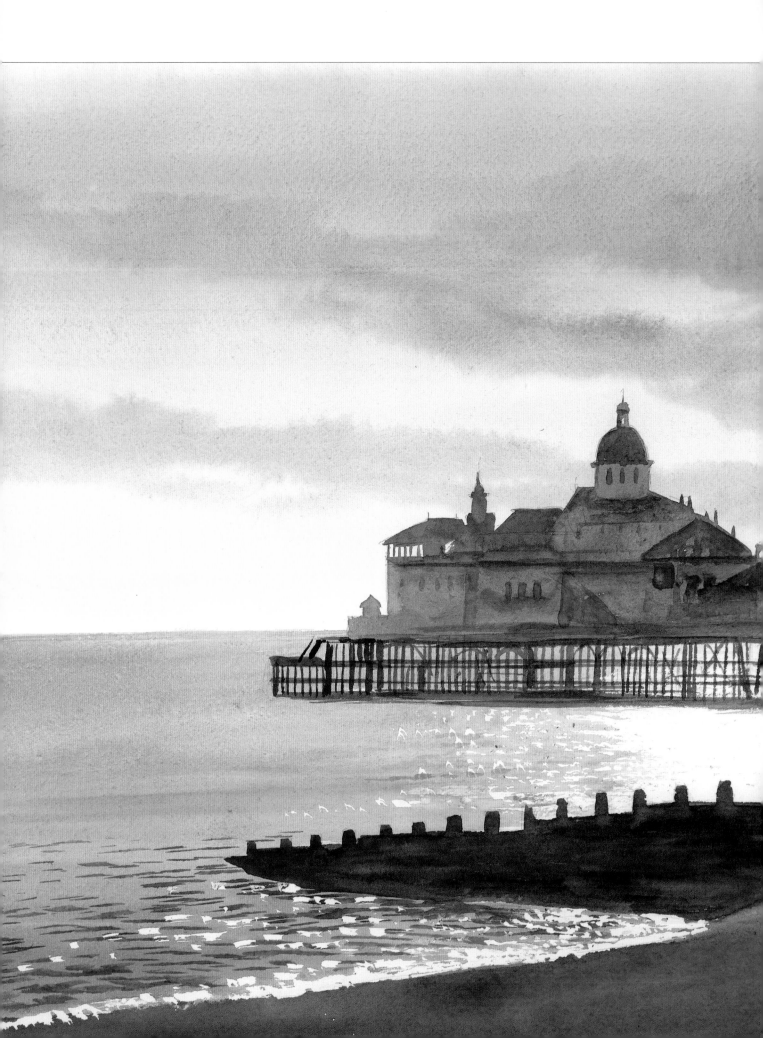

The finished painting.

Overleaf

Beside the Seaside

A more modest pier this time, but just as challenging. Masking fluid was used for the sun and its reflections. In paintings like this, keep an eye on how dark the pier and the foreground are, as the dark tones help to brighten the lights. The plastic card technique helps to pick out the detail on the rocks.

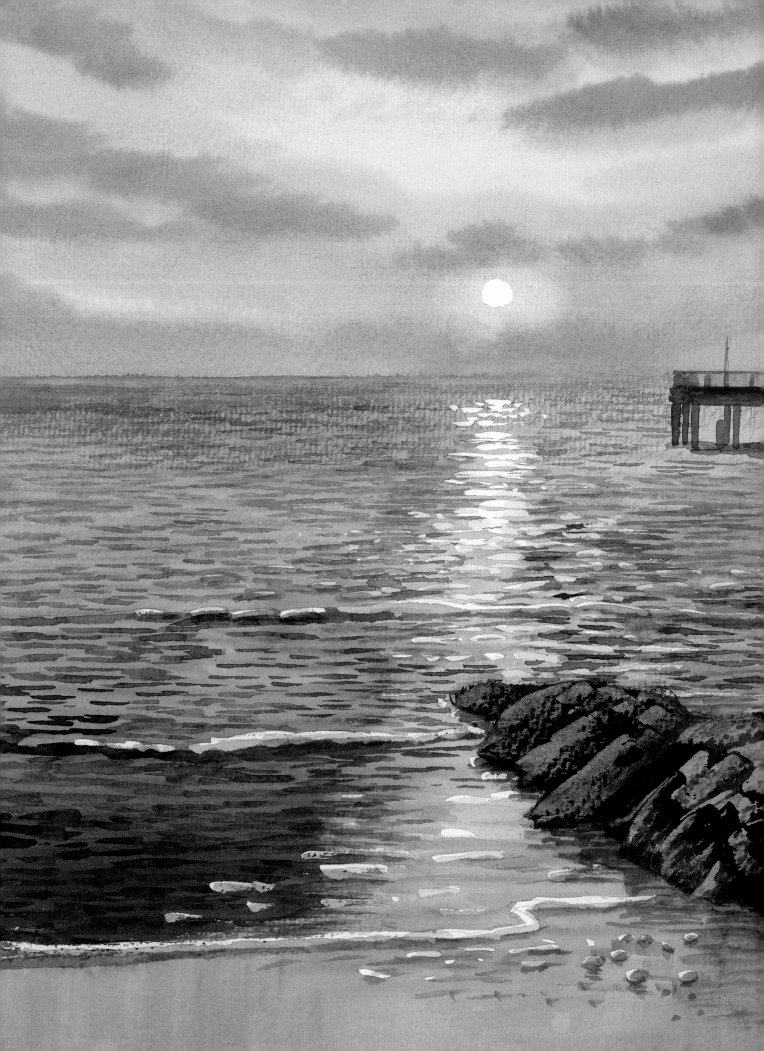

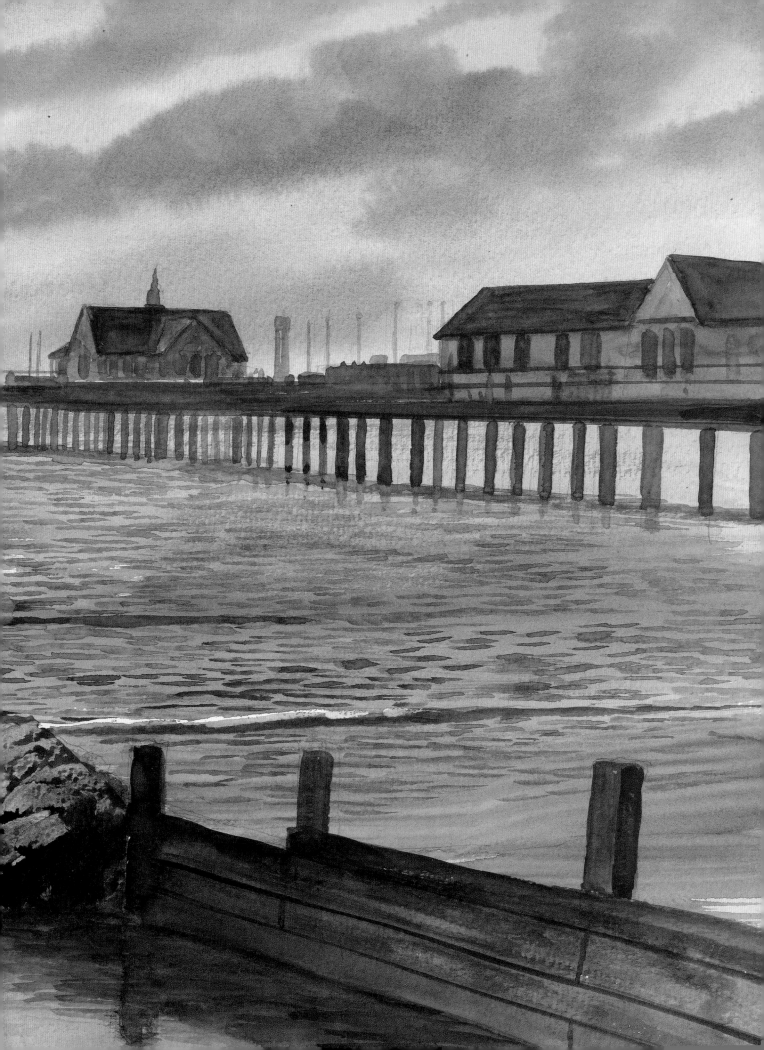

On the Rocks

This painting depicts the guardian of the coast line, the lighthouse, sitting high on a cliff top overlooking the drama of the stormy waters raging below. Dark contrasts help to heighten the impact of the storm, and the whites of the surf and foam are captured using masking fluid.

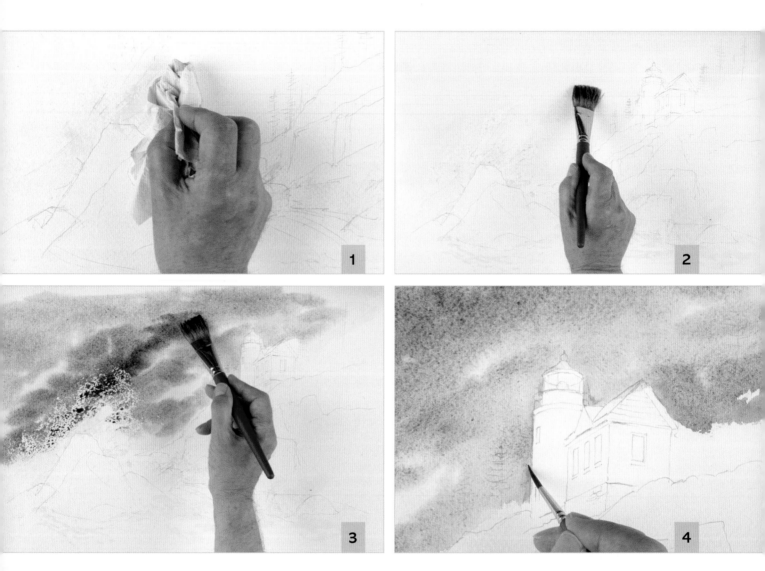

1 Draw the scene. Dip a scrunched piece of kitchen paper in masking fluid and dab it on to the painting to mask out the spray from the wave crashing on the rock.

2 When the masking fluid is dry, use the golden leaf brush to wet the sky area and brush in a pale mix of raw sienna.

3 Make a thicker mix of ultramarine and burnt umber and brush in clouds, wet into wet, leaving some gaps.

4 While the sky is still wet, use the small detail brush and the paint mix from the sky to tidy round the shape of the building.

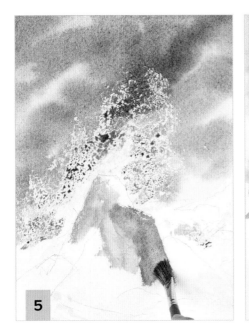

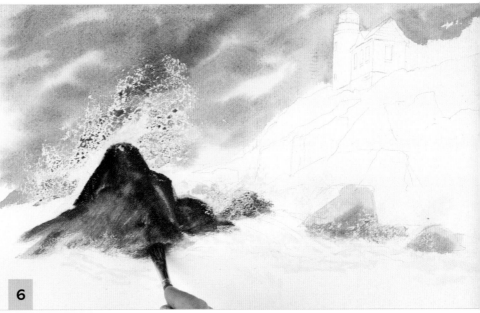

5 Take the foliage brush and paint the sunlit sides of the rocks with thick raw sienna, then the shaded sides with raw sienna and cobalt blue.

6 Paint a still thicker mix of ultramarine and burnt umber over the top.

7 Use the plastic card technique (see page 44), scraping over the surface of the paint to create texture and form, leaving dark marks for crevices.

8 Paint the cliff with thick cobalt blue, then paint a dark mix of ultramarine and burnt umber over the top. Again, use a plastic card to scrape out texture and shape in the cliff.

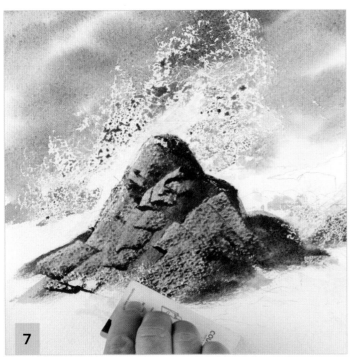

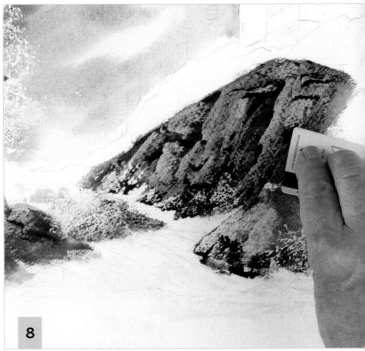

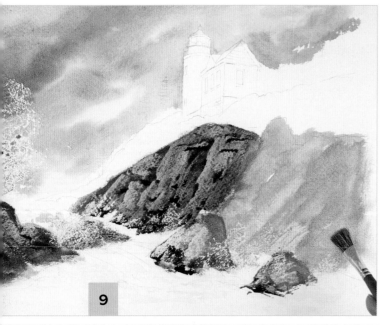

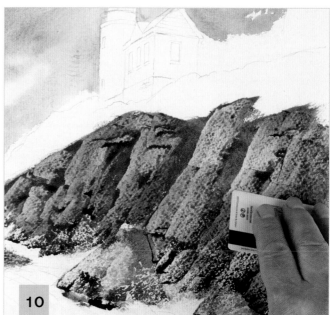

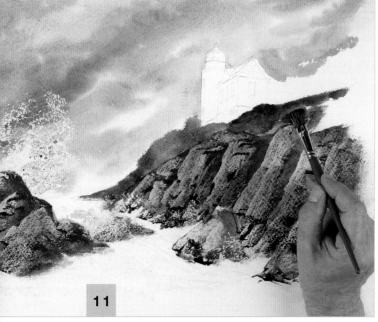

9 Paint the right-hand side of the cliff with raw sienna, then sunlit green.

10 Once again, paint the dark mix of ultramarine and burnt umber on top, and scrape out texture with the plastic card.

11 Mix country olive and burnt umber to paint the grassy cliff-top below the building.

12 Change to the small detail brush and mix midnight green and ultramarine. Paint the fir trees, starting with the trunks and adding branches fanning out.

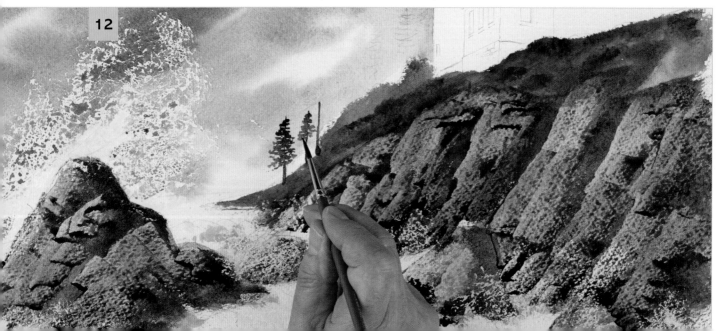

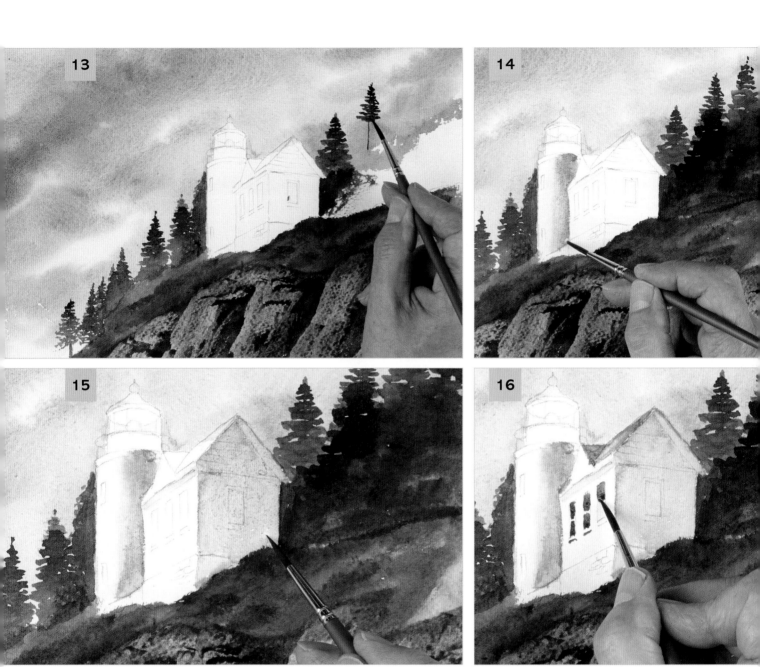

13 Continue painting trees on either side of the building, varying the mix of midnight green and ultramarine.

14 Use the large detail brush to paint the nearer trees and the massed trees to the right. Change to the medium detail brush and paint clean water onto the lighthouse. Make a pale mix of cobalt blue and shadow and paint the darker, shadowed part, blending into a paler mix and letting this drift into the clean water to suggest the cylindrical shape.

15 Continue suggesting the form of the building with the same mix. Paint the gable end.

16 Paint the roof with burnt sienna, then the windows with ultramarine and burnt umber.

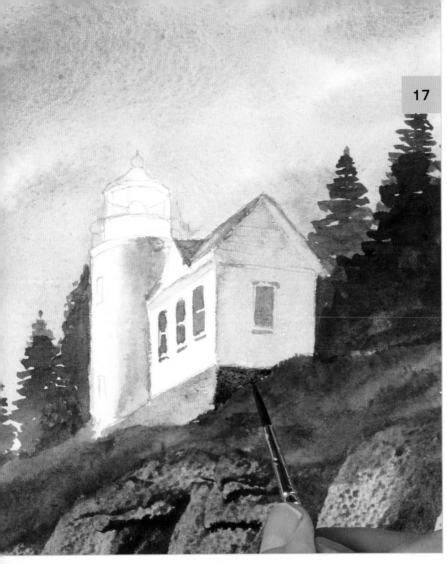

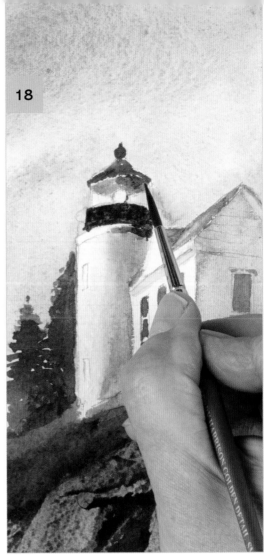

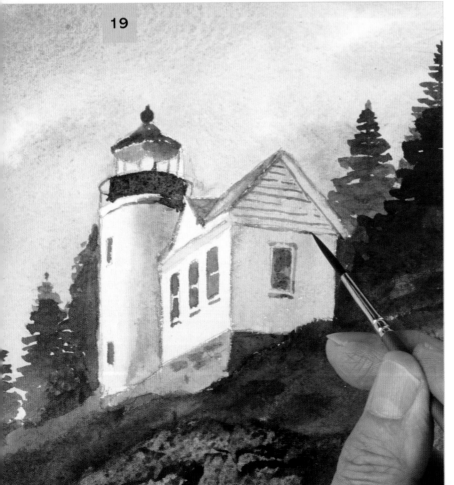

19

17 Paint the decking below the lighthouse with burnt umber, then mix in shadow to paint the shaded part.

18 Mix ultramarine and burnt umber and paint the top of the lighthouse and the detail.

19 Use the half-rigger and the same mix to paint weatherboard and other detail on the gable end.

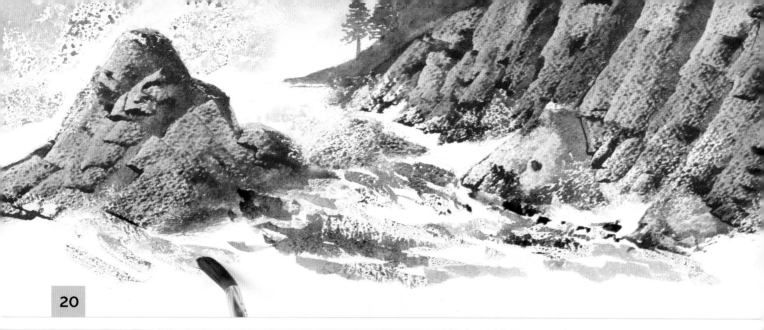

20

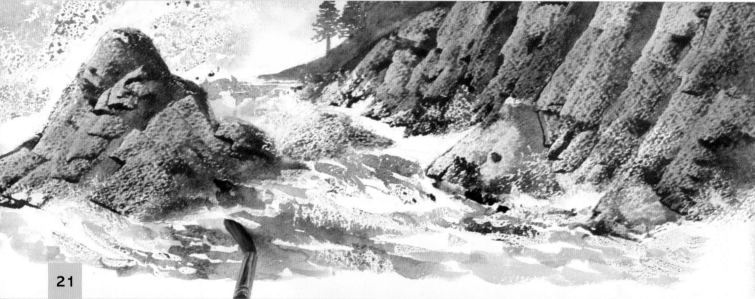

21

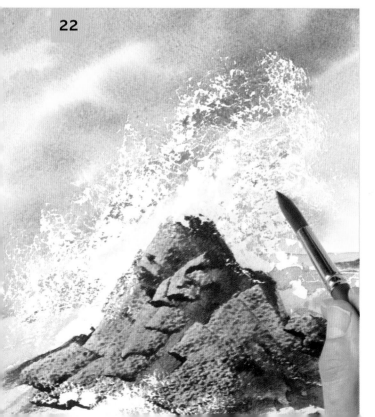

22

20 Make a mix of ultramarine and midnight green and use the large detail brush to paint wave shapes in the sea, creating a dark background to the masked area.

21 Add phthalo turquoise to the mix and continue paining more wave shapes in the water, leaving some white patches. Allow to dry.

22 Remove the masking fluid with clean fingers. Dab a pale mix of cobalt blue into the foam burst to give it shade and form.

Overleaf
The finished painting.

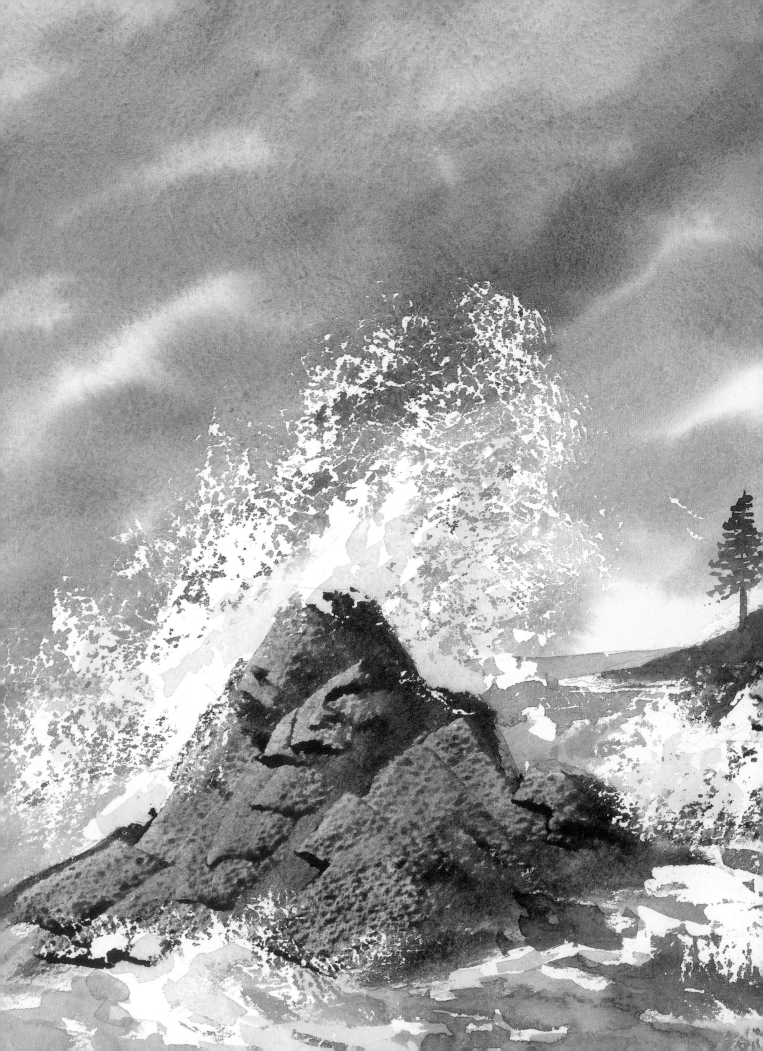

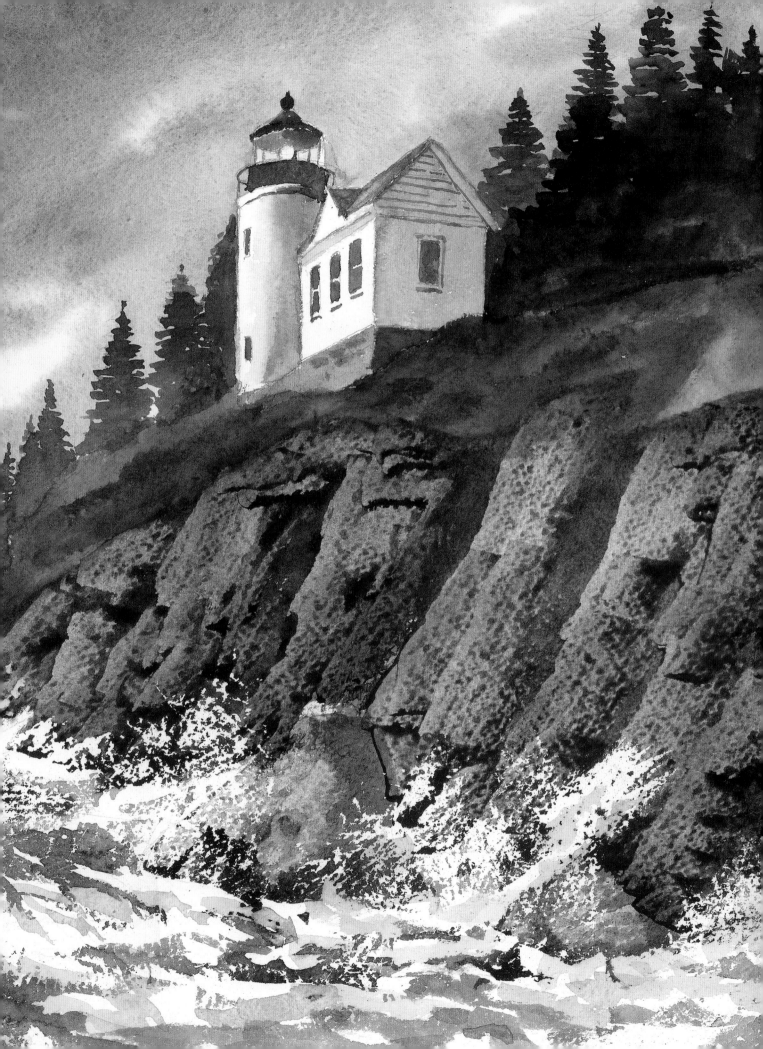

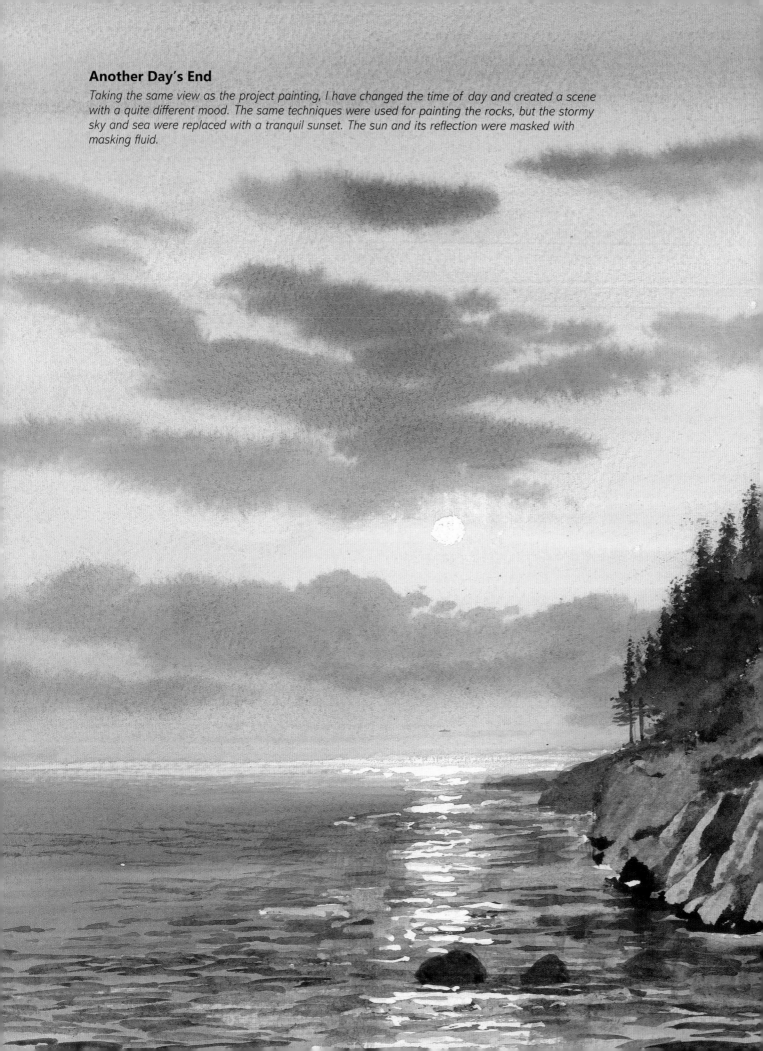

Another Day's End

Taking the same view as the project painting, I have changed the time of day and created a scene with a quite different mood. The same techniques were used for painting the rocks, but the stormy sky and sea were replaced with a tranquil sunset. The sun and its reflection were masked with masking fluid.

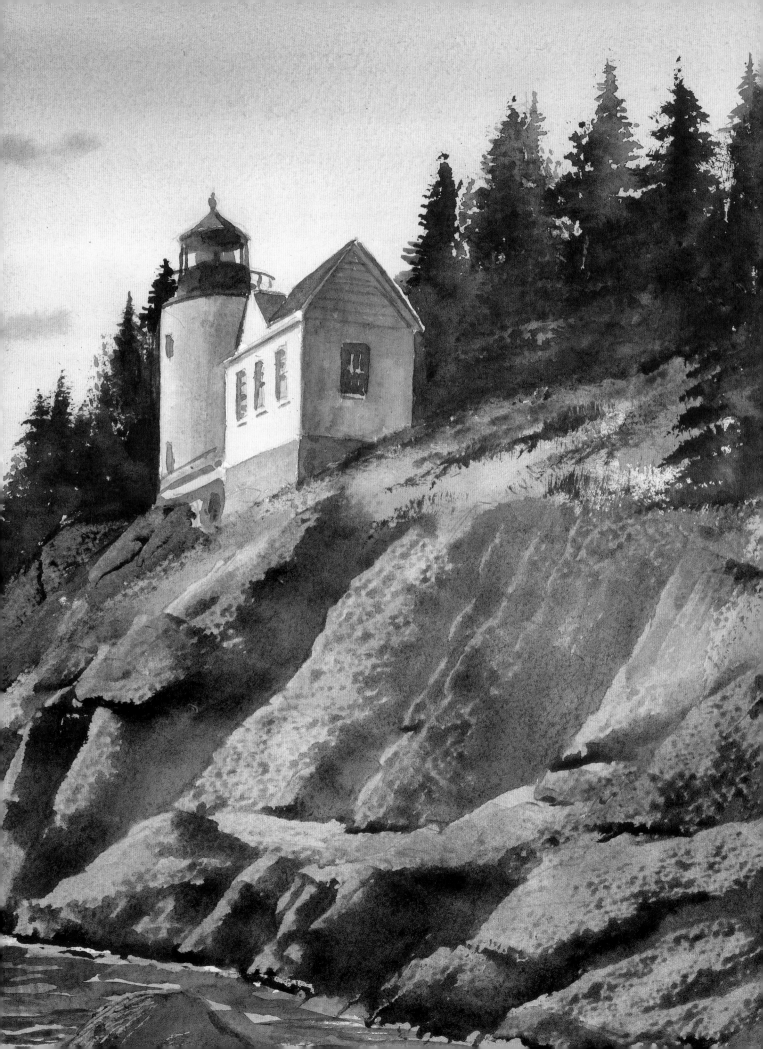

Sunlit Shore

The sight of the setting sun over the sea creates one of life's finer moments; the scene is always changing and there is never a repeat performance. Painting a sunset is rewarding as well as challenging. This scene has plenty of appeal: beaches, a receding headland, the need to create depth and a strong foreground with sparkling sunlight on the sea.

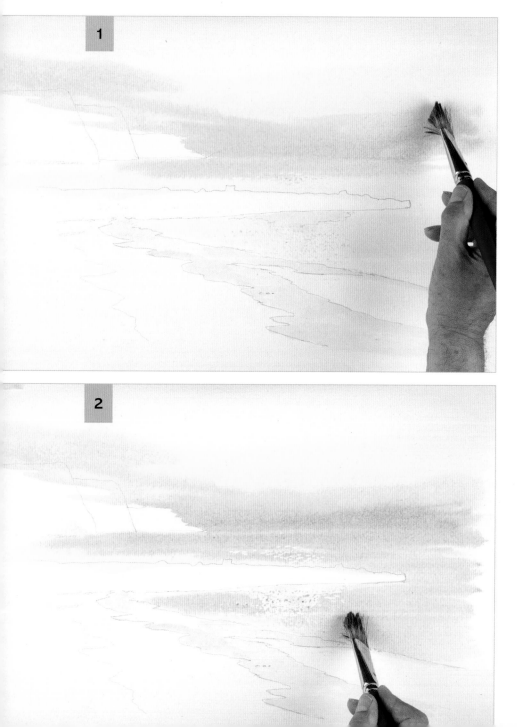

1 Draw the main outlines of the scene. Mask the shoreline and the sparkles in the water with masking fluid and an old brush. Take the golden leaf brush and wet the sky and water areas, leaving the cliffs, groyne and beach dry. Paint a pale wash of cadmium yellow over the lower sky and the upper part of the water.

2 Make a thicker mix of cadmium red and cadmium yellow and paint this in over the lower sky and the water, working wet into wet. Add permanent rose to the mix and paint stronger strokes in the lower sky and water.

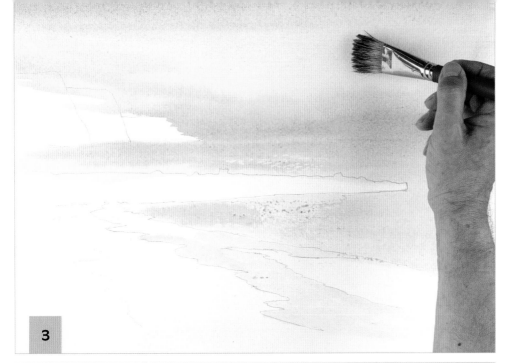

3 While the painting is still wet, paint horizontal strokes of cobalt blue across the top of the sky, blending it down into the yellow.

4 Mix permanent rose with the cobalt blue and paint it in the foreground water, over the sparkles, to create a dark background for the masking.

5 Using the same mix, dot in clouds wet into wet.

6 Paint the beach with a strong mix of shadow and burnt sienna, going up to the masked surf.

7 Make a darker mix of ultramarine, shadow and burnt umber and paint this, wet into wet, on the left-hand side of the beach, then along the water's edge, under the surf.

8 Mix cobalt blue and a touch of shadow and use the large detail brush to paint the furthest part of the cliffs and the rock standing out against the sunset.

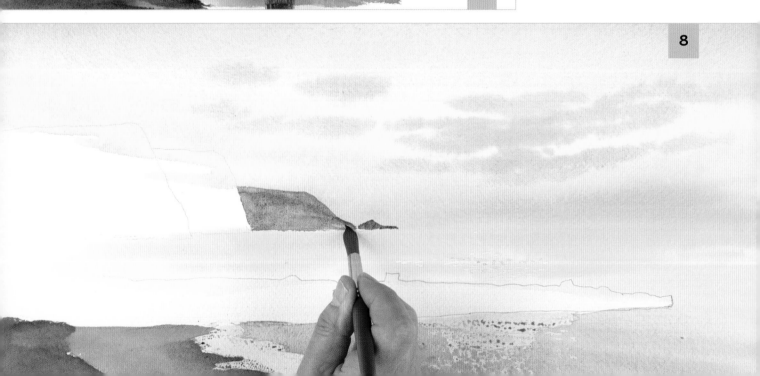

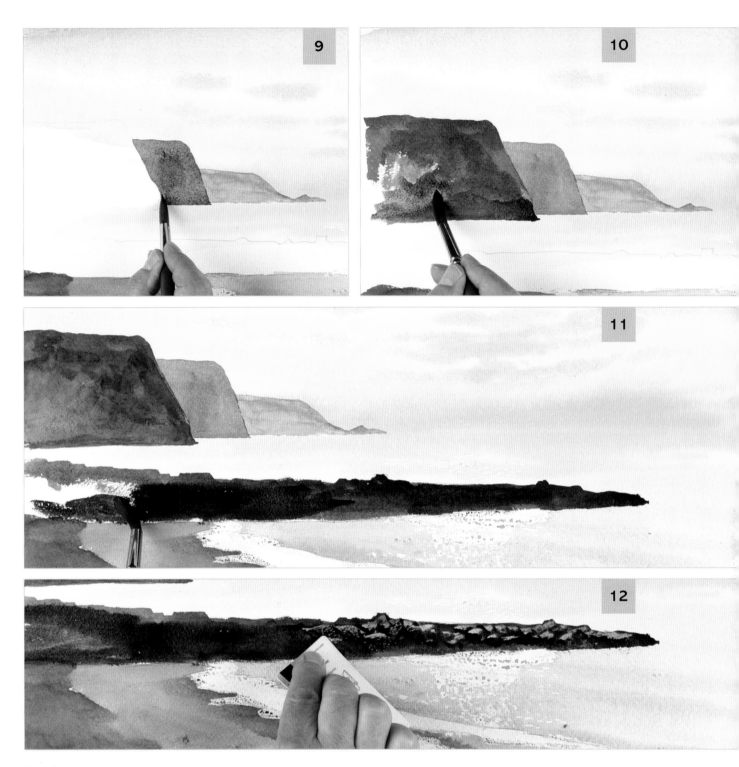

9 When the first cliff is dry, paint the next one along with a darker mix of the same colours.

10 Mix shadow and burnt umber, and when the middle cliff is dry, paint the nearest one with this darker mix. The sequence of the cliffs getting darker as they become nearer creates the impression of depth in the painting.

11 Paint the groyne with a very dark, thick mix of ultramarine, burnt umber and shadow.

12 Use the corner of a plastic card to scrape out texture and rocky shapes to suggest the groyne catching the light.

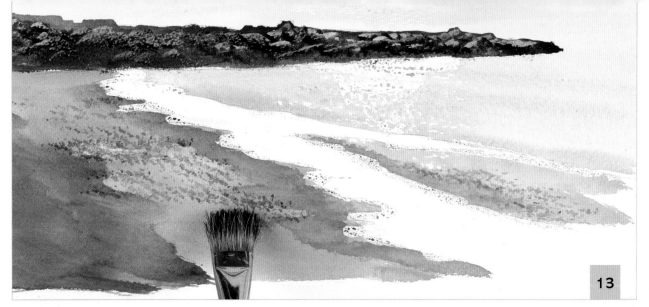

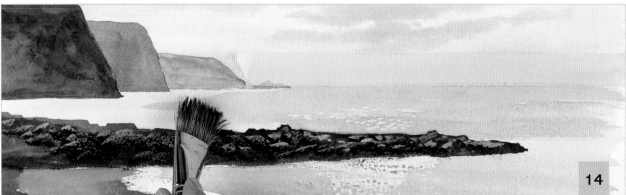

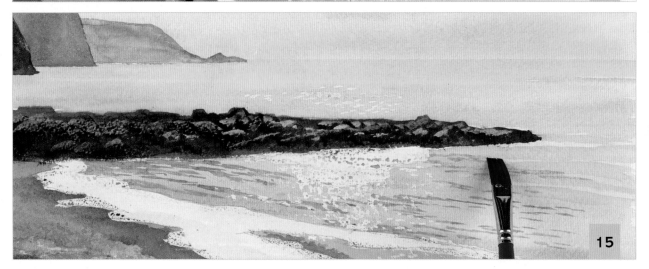

13 Stipple a more dilute mix of ultramarine, burnt umber and shadow onto the beach to create texture.

14 Place a strip of masking tape above the horizon to allow you to paint a straight line. Mix cadmium red and permanent rose and sweep this beneath the masking tape. Add a tiny bit of cobalt blue to the mix lower down. Allow to dry, then remove the masking tape carefully.

15 Use a flat 13mm (½in) synthetic brush to paint little horizontal strokes of cobalt blue and shadow to suggest ripples in the water below the groyne. Allow to dry.

16 When the painting is dry, remove the masking fluid with a clean finger.

17 Mix cadmium yellow and permanent rose and use the large detail brush to paint in the foam area, leaving bits of white to suggest the texture. Add a touch of shadow in the foregound, but leave the foam white near the sparkles.

18 Change to the small detail brush and paint tiny ripples with shadow under the groyne.

19 Use white gouache to paint a few extra sparkles.

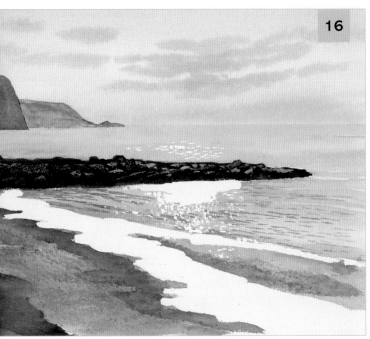

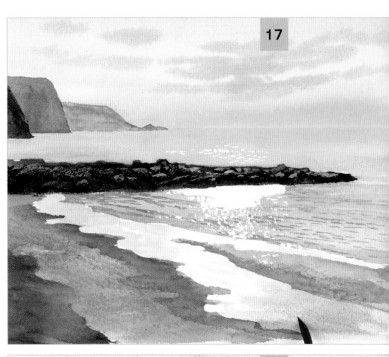

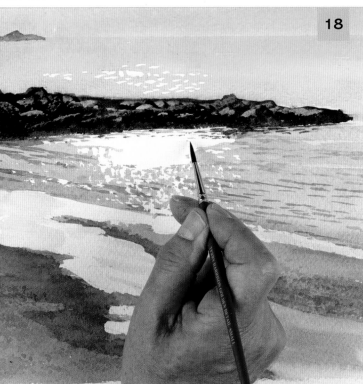

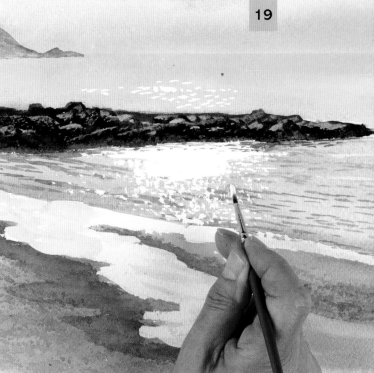

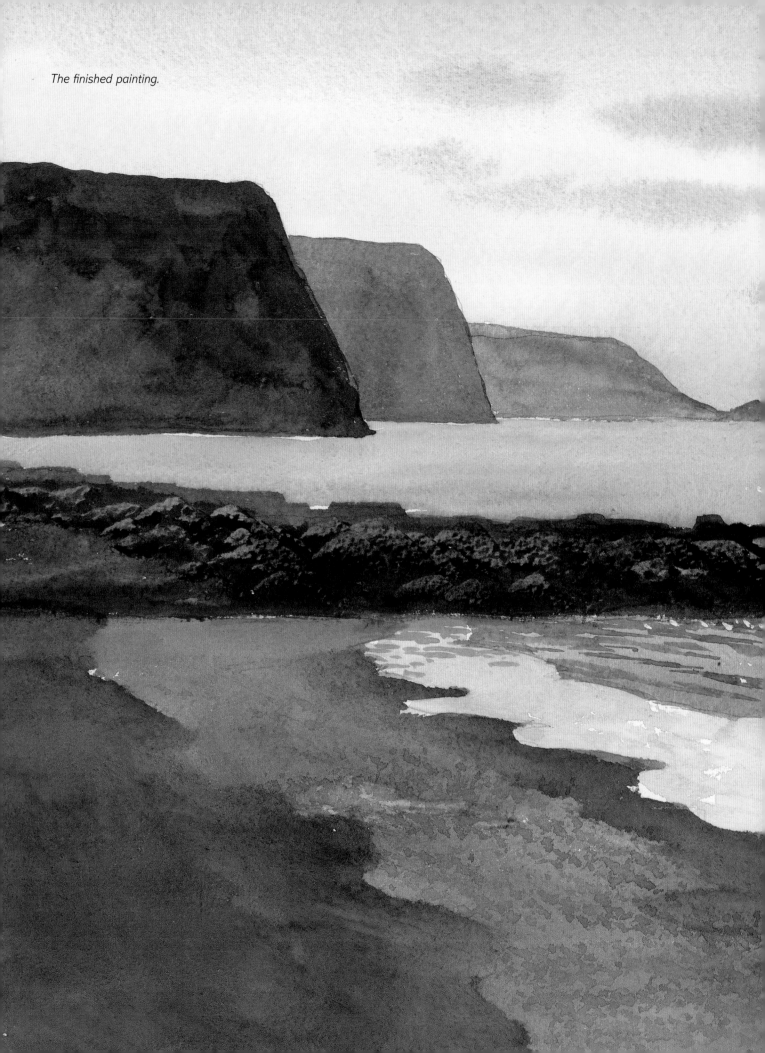

The finished painting.

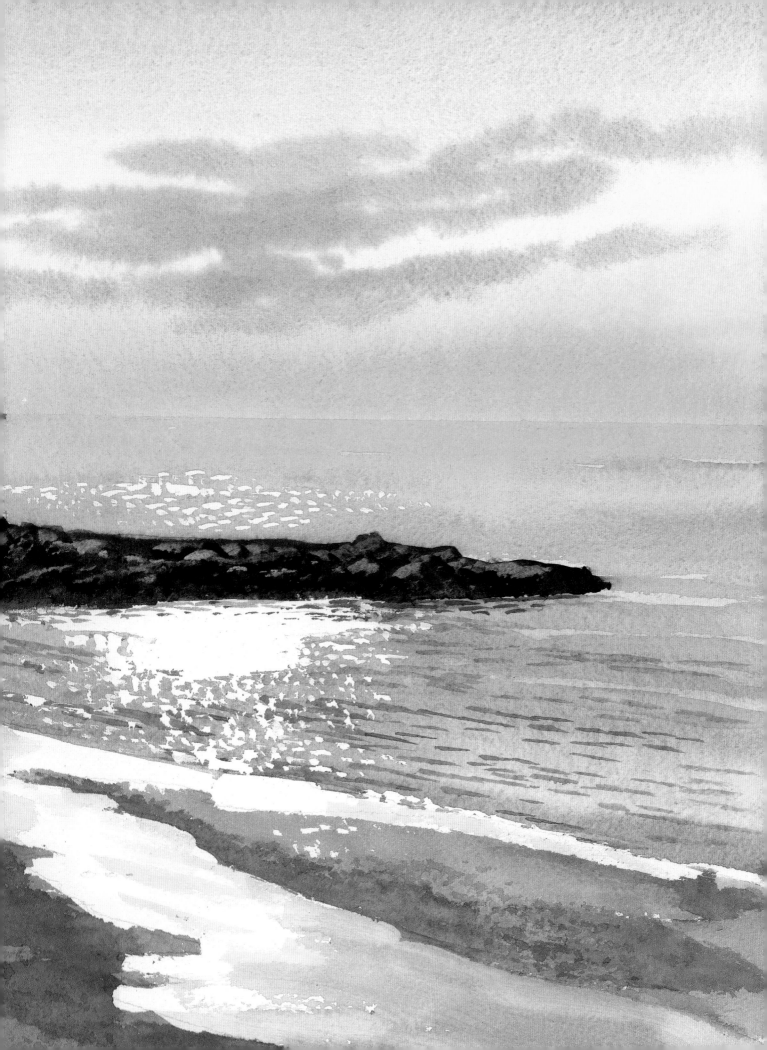

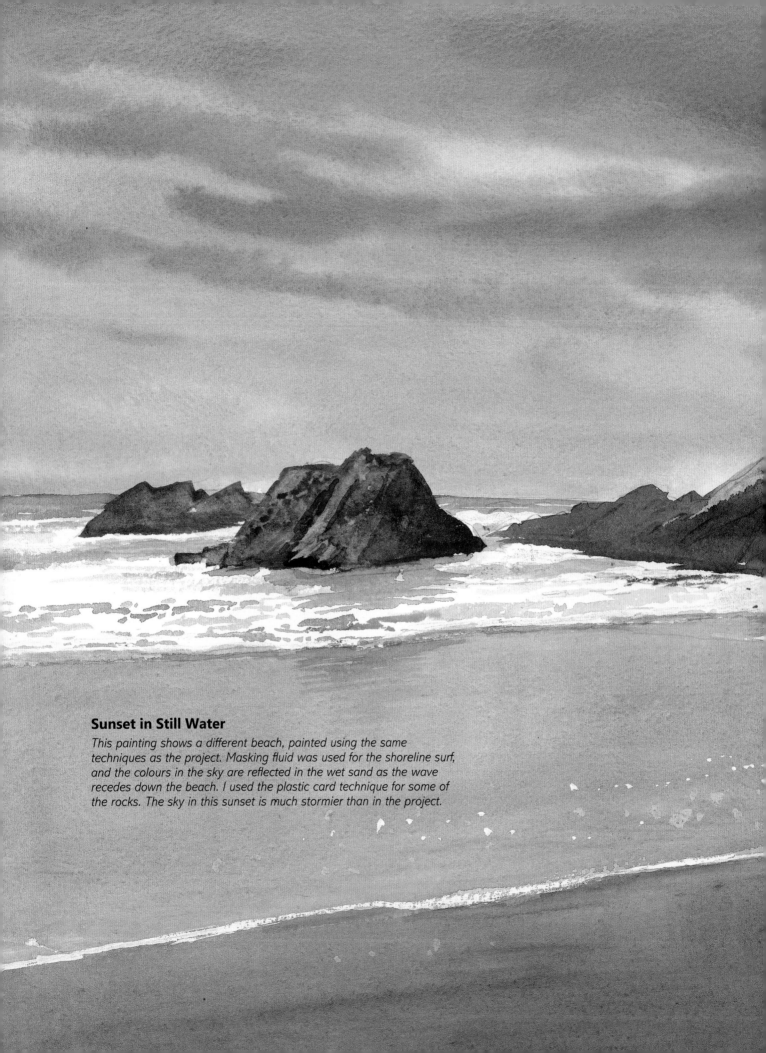

Sunset in Still Water

*This painting shows a different beach, painted using the same
techniques as the project. Masking fluid was used for the shoreline surf,
and the colours in the sky are reflected in the wet sand as the wave
recedes down the beach. I used the plastic card technique for some of
the rocks. The sky in this sunset is much stormier than in the project.*

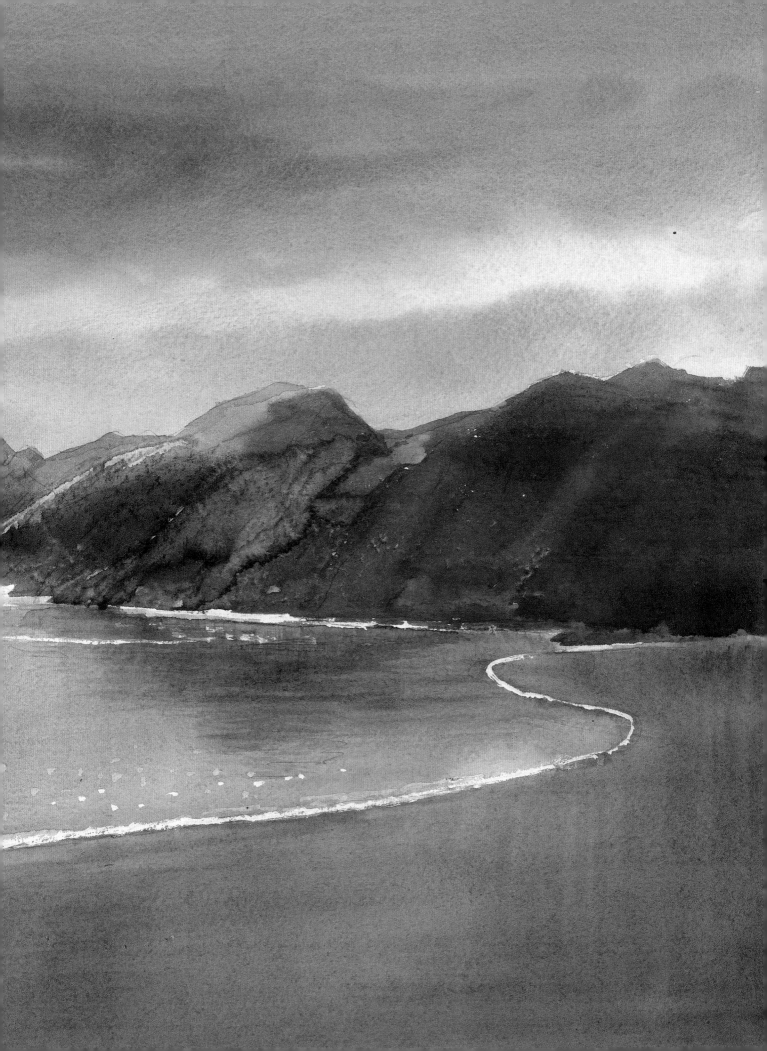

Lighthouse in the Evening

This sunset was inspired by my favourite painting of all time,
J M W Turner's The Fighting Temarare. I have substituted a lighthouse as the
focal point in place of Turner's ship. I have reproduced this sunset many
times, every one different in some way, but always a pleasure to paint. This
painting features a lifting out technique using a coin wrapped in kitchen
paper to create the sun.

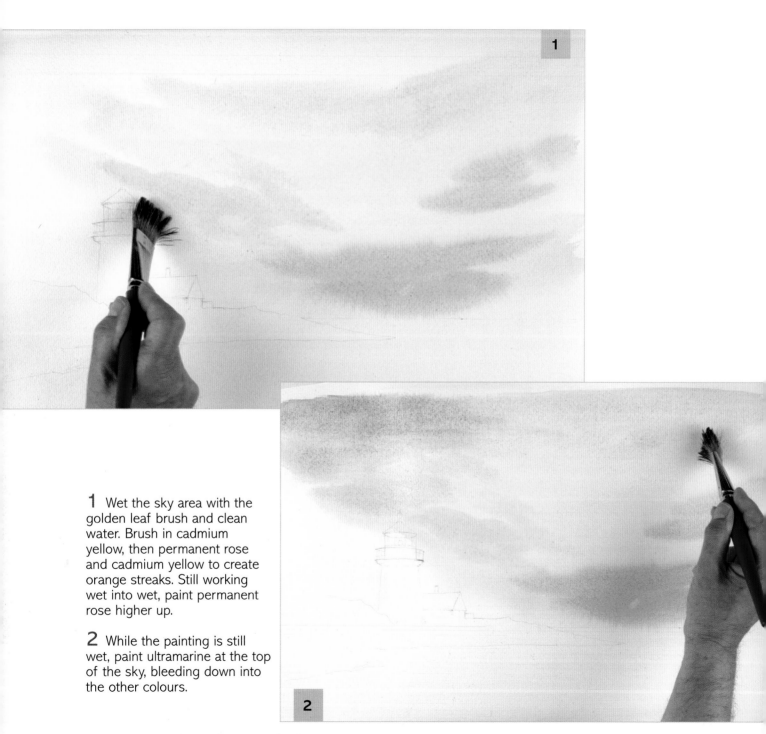

1 Wet the sky area with the
golden leaf brush and clean
water. Brush in cadmium
yellow, then permanent rose
and cadmium yellow to create
orange streaks. Still working
wet into wet, paint permanent
rose higher up.

2 While the painting is still
wet, paint ultramarine at the top
of the sky, bleeding down into
the other colours.

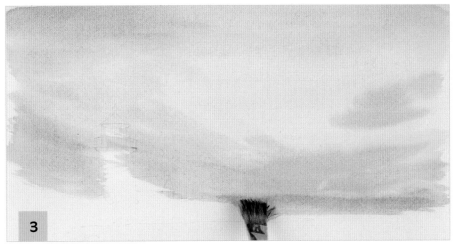

3 Paint more ultramarine at the bottom of the sky, making it stronger just above the horizon.

4 Mix permanent rose, cadmium red and a touch of shadow and paint clouds wet into wet. Add a touch of ultramarine to darken them.

5 Wrap a small coin in kitchen paper and use it to stamp out a sun shape in the wet sky.

6 The sun revealed.

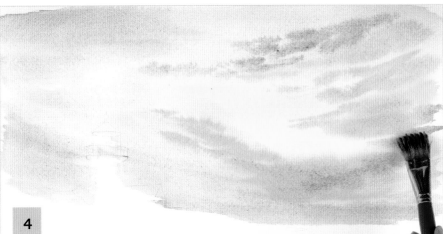

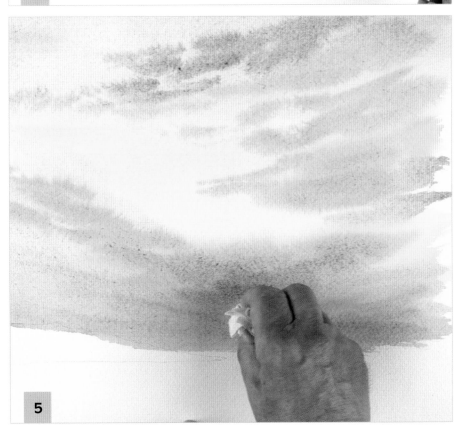

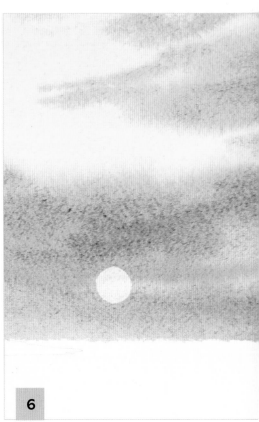

7 Paint the sea beneath the strongest sunset colours with horizontal sweeps of the golden leaf brush and a mix of permanent rose, cadmium red and cadmium yellow. While this is wet, brush ultramarine in from the left, then the right, to blend with the orange.

8 Pull a damp foliage brush down beneath the sun shape to lift out colour, creating the sun's reflection.

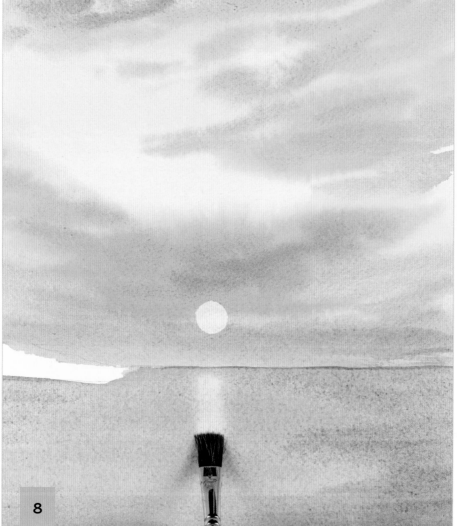

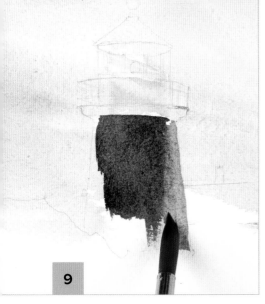

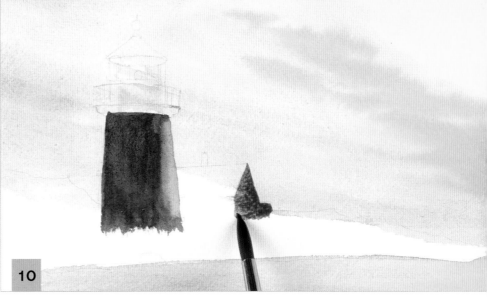

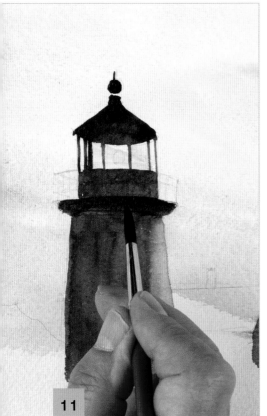

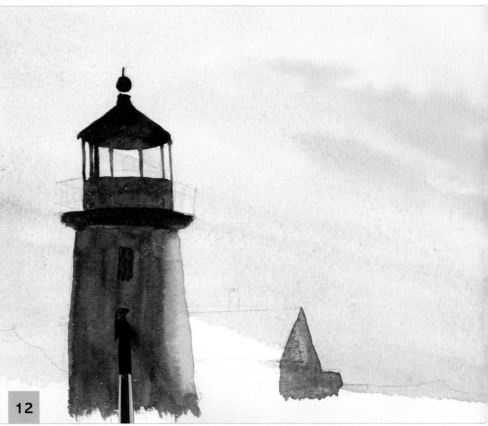

9 Mix cadmium yellow and cadmium red and paint the right-hand side of the lighthouse in the sunset glow, using the large detail brush. Paint a strong mix of shadow and cobalt blue on the left, blending it into the wet orange to create the cylindrical look.

10 Paint the gable end of the building with cadmium red, cadmium yellow and shadow. Allow to dry.

11 Change to the medium detail brush and paint the shape and detail of the lighthouse with a dark mix of ultramarine, burnt umber and shadow. You can use a ruler to help you paint straight lines.

12 Paint the windows with the same mix.

13 Paint the railings round the light with the half-rigger and the ultramarine, burnt umber and shadow mix.

14 Use the medium detail brush and the same mix to paint the darker parts of the other building.

15 Change to the large detail brush and paint the rocky land with the same mix.

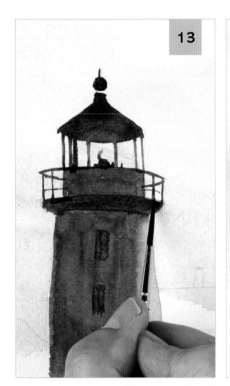

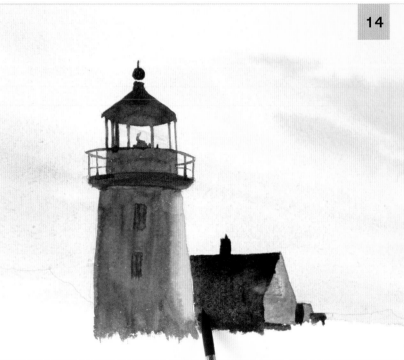

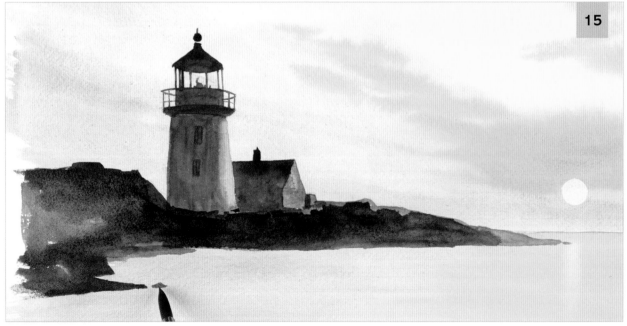

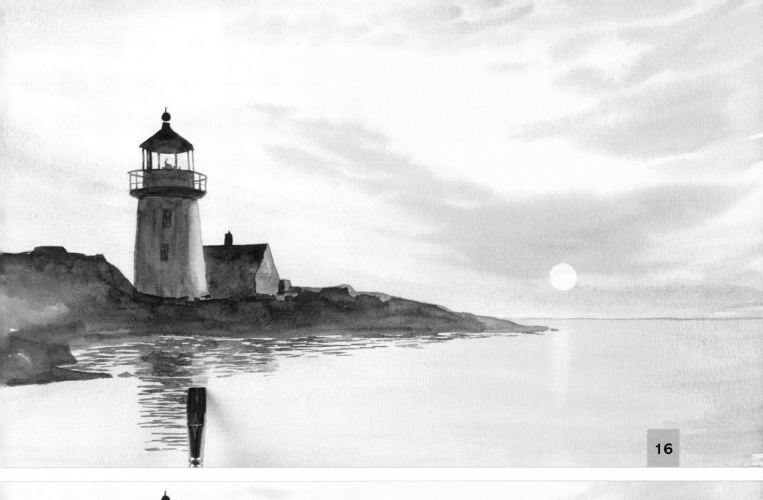

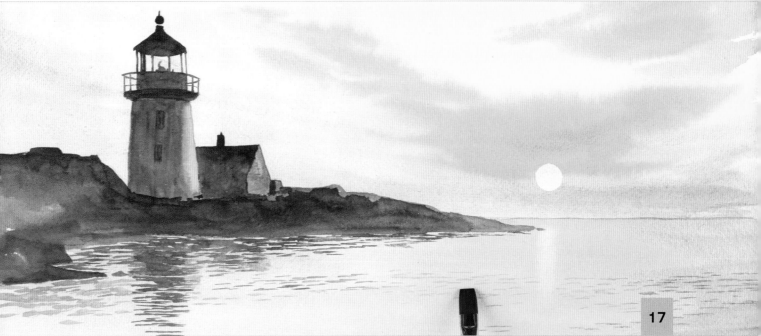

16 Use the flat 13mm (½in) synthetic brush with the same mix to paint rippled reflections under the land and tower in short horizontal strokes. Add more ripples in cadmium yellow and cadmium red to reflect the sunlit parts of the buildings.

17 Paint more ripples in the sunset area of the sea with a mix of ultramarine, burnt umber and shadow.

Overleaf
The finished painting.

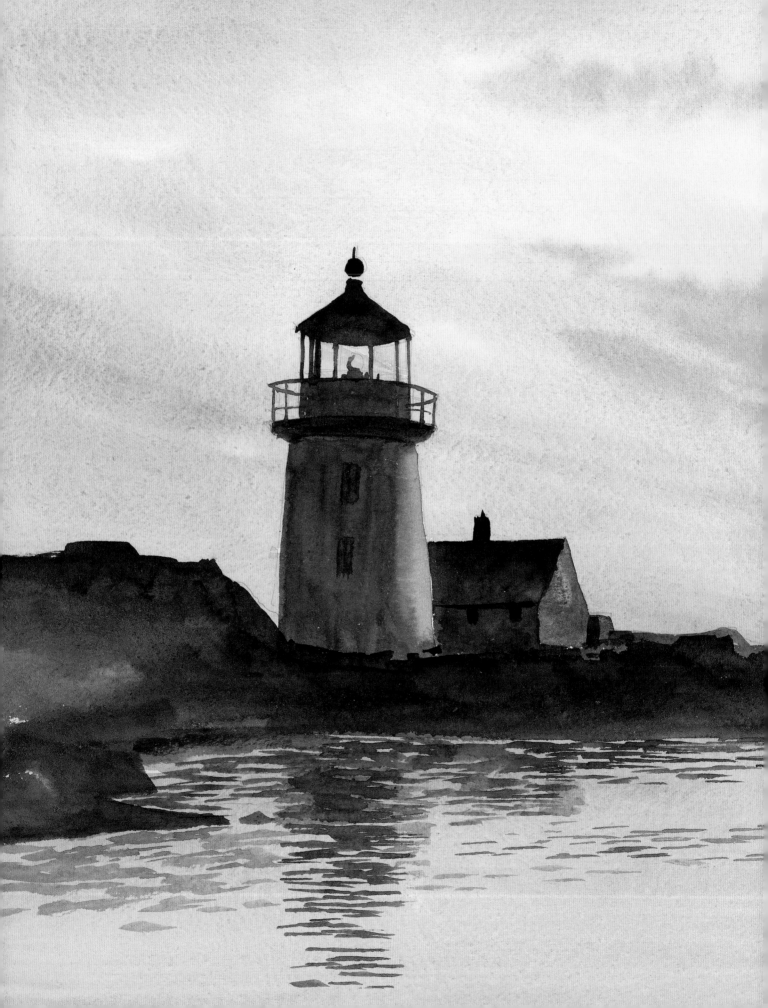

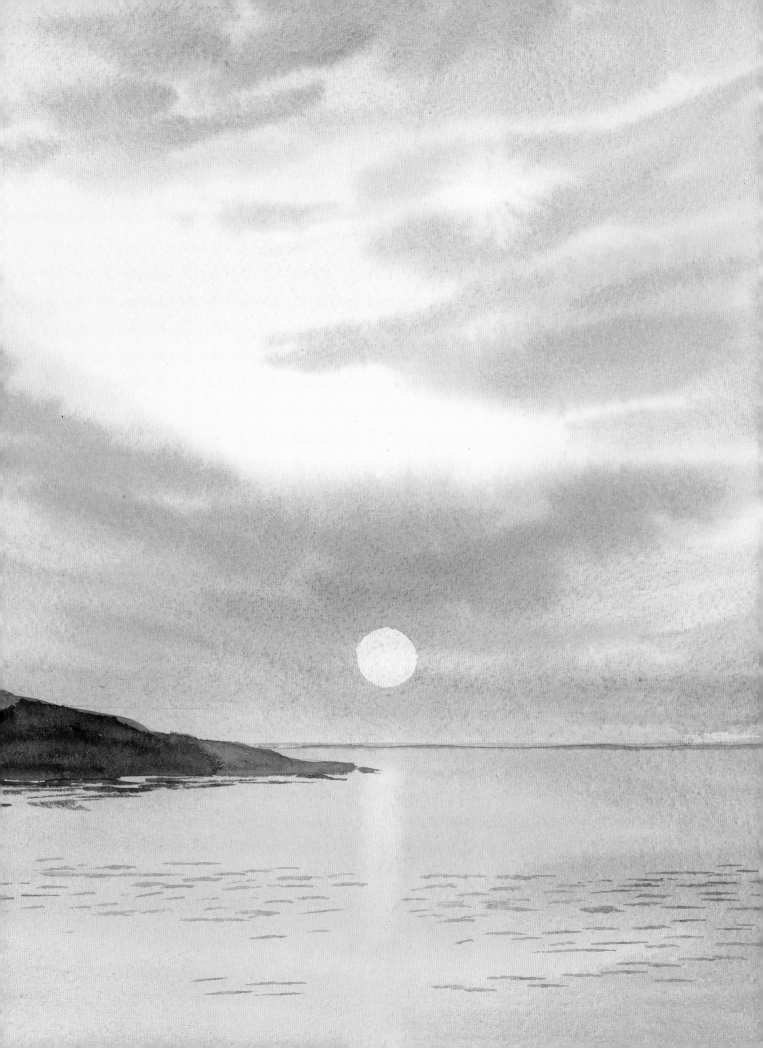

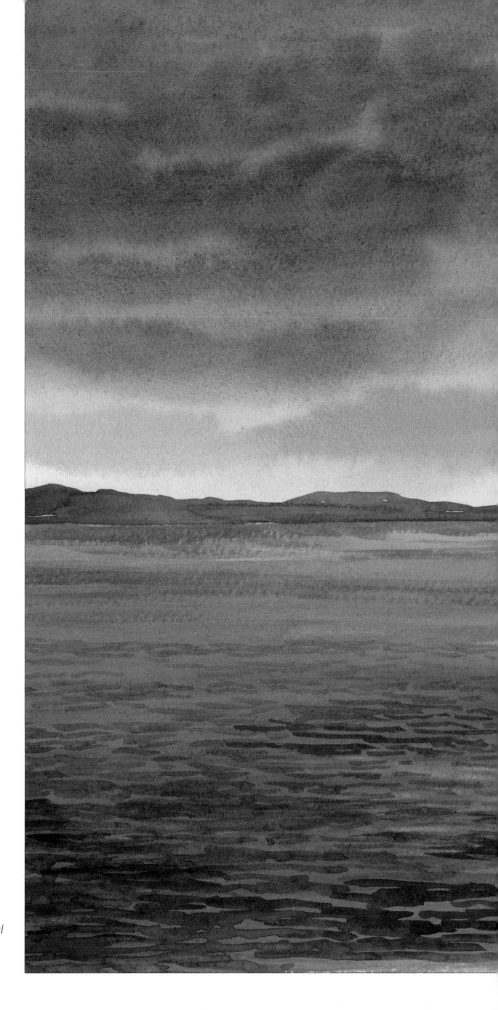

Heading for Port

The small boat sails towards the setting sun, the sails silhouetted against a golden sky. All is calm, but storm clouds are moving in. The darkest part of this painting is the boat, which is the focal point, and this is balanced by the storm clouds. The reflections of the boat and clouds in the water were painted using short horizontal brush strokes and the light ripples were lifted out using a flat brush.

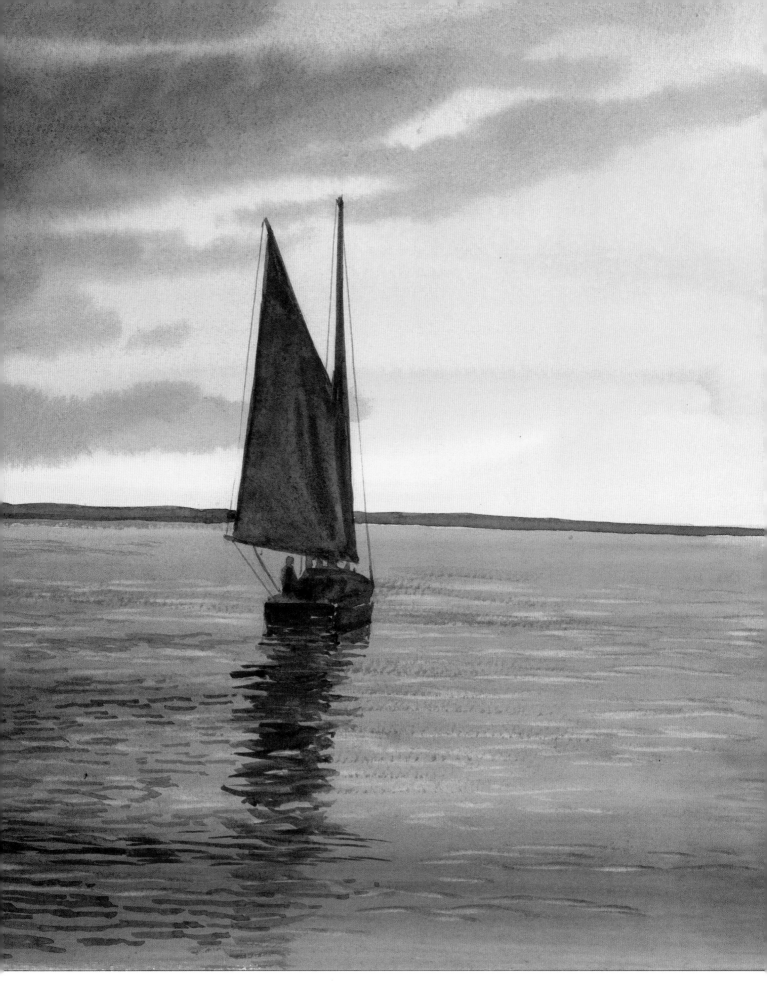

Index